IMAGES
of America

SPARKS

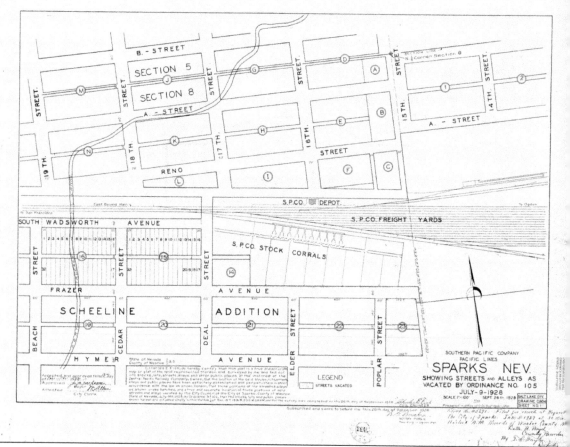

The stock corrals and freight yards were remodeled and enlarged by the railroad in 1928. The August 9, 1927, *Reno Evening Gazette* reported that railroad officials approved plans to add 20 chutes and one additional track so that "livestock could be loaded on both sides of the corral by eastbound and westbound trains without interference," thereby doubling the capacity of the corrals. The Sparks City Council vacated streets and alleys on July 9, 1928, through Ordinance No. 105, allowing the railroad to begin altering the stock yards. (Washoe County Recorder.)

On the Cover: George A. Abbay, yardmaster in Sparks from 1905 through 1945, is thought to have taken this photograph of the yard crew on steam engines 1150 and 1151 in 1911. Abbay's sons Fred and George V. worked for the railroad as roundhouse foreman and yardmaster, respectively. George V. worked for the railroad from 1926 to 1960. The Abbay family included three generations of railroad workers, with George working for Central Pacific and his son George A. and grandson George V. working for Southern Pacific. (Dick Dreiling.)

IMAGES
of America

SPARKS

Joyce M. Cox

ARCADIA
PUBLISHING

Published by Arcadia Publishing
Charleston, South Carolina

Library of Congress Control Number: 2016962856

For all general information, please contact Arcadia Publishing:
Telephone 843-853-2070
Fax 843-853-0044
E-mail sales@arcadiapublishing.com
For customer service and orders:
Toll-Free 1-888-313-2665

Visit us on the Internet at www.arcadiapublishing.com

To my husband, Greg Cox, and son, Alex J. Cox, and my sisters, Janice Weide and Carolyn Crowson. Thanks for your support and love.

CONTENTS

ACKNOWLEDGMENTS

This book could not have been completed without the help of many people. Thanks to Kelly Reis at the Sparks Heritage Foundation and Museum for finding and scanning photographs and editing my manuscript; Michael Maher and Karalea Clough at the Nevada Historical Society Library for searching their manuscript collections and photograph collections; Lee Brumbaugh, Sheryln Hayes-Zorn, and David Lowndes of the Nevada Historical Society for scanning many photographs; Jerry Fenwick, Dick Dreiling, and Pat Ferraro Klos for the use of photographs from their extensive collections; Natacha Faillers at the Nevada State Library, Archives, and Records for scanning photographs; Mitch Ison and Patrick C. Jackson from the Nevada Department of Transportation (NDOT) for the use of images in the NDOT photograph collection; Eric Moody and Dick Dreiling for reading and editing the book; Sandy Gualano, chief deputy recorder at the Washoe County Recorder's Office, for finding and scanning maps; and my Arcadia editor Caitrin Cunningham for answering all of my questions.

The images in this book come from the Sparks Heritage Foundation and Museum (Sparks Museum); Nevada Historical Society (NHS); Nevada State Library, Archives, and Records (NSLAR); Nevada Department of Transportation (NDOT); Washoe County Recorder (WCR); and the private collections of Jerry Fenwick, Dick Dreiling, and Pat Ferraro Klos.

INTRODUCTION

The earliest settlement in the Lower Truckee Meadows, in the area that became Sparks, was a trading post known as Jamison's (or Jameson's) Station in 1852. Emigrants going to the California goldfields had just crossed the Forty-Mile Desert—with no water and little food for their animals—when they came to the lush lands along the Truckee River.

H.H. Jamison sold much-needed supplies to these emigrants and often bought their cattle to fatten up and resell. Jamison appears to have left the area in 1853, and there was very little additional settlement until George F. Stone and Charles C. Gates began taking emigrants across the Truckee River on their rope ferry in 1857. Stone and Gates' Crossing, a trading post and ferry crossing, was west of Jamison's Station. By 1860, Stone and Gates had a toll bridge and a large two-story hotel known as the Farmers (or Glendale) Hotel. This area was part of Washoe County in Nevada Territory.

When a post office was established at Stone and Gates' Crossing, the area was renamed Glendale. Glendale was large enough to have a restaurant, saloons, a blacksmith, and a meat market. The Stone and Gates' School, later known as the Glendale School, one of the earliest schools in Washoe County and Nevada, was built in the spring of 1864. When the Central Pacific Railroad came into the valley in 1868, creating Reno and becoming the main means of transportation for those going to California, pioneers stopped using the Glendale Bridge. Auburn, a small village northwest of Glendale and two miles from Stone and Gates' Crossing, was settled by mine and mill workers of the Washoe United Consolidated Gold and Silver Mining Company in 1863. By 1865, the mine and mill workers left the area searching for gold in other locations. Vista, four miles east of downtown Sparks, was a flag station for the Central Pacific and then Southern Pacific Railroads. Portions of these settlements would later be annexed to become elements of Sparks.

Ranchers and farmers in the area sold their crops to the residents of Reno and miners in Virginia City. Farmers grew apple, peach, cherry, and plum trees, along with alfalfa, onions, cabbages, beets, and potatoes. Ranchers had large herds of cattle, sheep, and horses.

Groups of Paiute and Washoe Indians camped along the Lower Truckee River for thousands of years, and Native Americans continued to camp near Stone and Gates' Crossing and Glendale. Paiute men worked on area ranches and were described in Elmer Rusco's article "Formation of the Reno-Sparks Tribal Council, 1934–1939" in the *Nevada Historical Society Quarterly* as "very good steady workmen." There may be an old Indian burial ground near the Orr Ditch and east of the sites of the old Gault and Mapes Ranches.

Sparks started as a railroad town that sprang up overnight soon after the Southern Pacific Railroad acquired the Central Pacific Railroad in the late 1890s. Edward H. Harriman, president of Southern Pacific, planned to reroute the tracks through Nevada to eliminate dangerous curves and steep grades and to build newer and larger railroad shops. The roundhouse, car repair shops, and machine shops in Wadsworth, about 30 miles east of Reno, closed. Wadsworth, the second-largest city in Washoe County in 1900, then had 1,309 residents, along with hotels, saloons,

churches, schools, a library, a grocery, and variety stores. Most of these people moved with the railroad to Sparks. Railroad officials looked at locations near Reno for their new shops and new town but selected the Thomas or Martin Ranch and the Mary Wall Ranch four miles east of Reno for the new railroad division point.

William Hood, the chief engineer of the Southern Pacific Railroad, made an announcement to Wadsworth railroad employees at a meeting on April 30, 1902, that the division point was to be moved to land east of Reno. Work began to level and raise the new land with tons of rock and dirt, and construction started on the new shops. Carloads of dirt, clay, and gravel were hauled for six months from Poor's Ranch near Mountain View Cemetery to level and fill in the swampland on the ranches. The railroad offered deeds to residential lots—50 feet by 140 feet in size—to Wadsworth railroad workers for $1; railroad officials then put names in one hat and lot numbers in another to determine who got which lot. About 300 railroad workers and their families began moving to Sparks in the spring of 1904. The railroad moved employees' houses to the new town on flatcars and boxcars, but employees were responsible for taking the houses apart and putting them back together. People brought furniture, appliances, livestock, fruit trees and shade trees, plants, and pets to the new town. Houses were reassembled and put on new foundations in the "Railroad Reserve" by September 10, 1904. The Reserve was on four blocks between Tenth and Fifteenth Streets, with 16 lots on each block. There were also three lots on Harriman Avenue, later B Street. Deeds did not allow businesses or saloons on the Reserve lots.

The new town was first called East Reno, New Wadsworth, or Harriman. On May 27, 1904, the town was finally named Sparks after Nevada's popular governor John Sparks. In 1903, the population in this area was estimated to be around eight people, but by 1904, it measured between 1,200 and 1,500. Sparks became official when the town plat was filed with the Washoe County registrar on April 23, 1904. A bill to incorporate Sparks was introduced in the Nevada legislature on February 25, 1905, and was passed unanimously shortly thereafter and signed by Governor Sparks on March 15, 1905. The governor, known for his generous hospitality, invited all of the new Sparks residents to his Alamo Ranch south of Reno for a barbecue of beef, sheep, and possum.

Since Wadsworth had become almost a ghost town, many businesses followed their customers to Sparks, and businessmen from Nevada and California also looked to Sparks for new opportunities. Patrick "Paddy" Reddy opened the Surf Saloon with a large dining room and kitchen on Harriman Avenue in 1904. The Bank of Sparks opened in January 1905 with William J. Harris serving as its first president. H.W. Patton started the *Harriman Herald* newspaper in January 1904, then sold it in July, after which it was renamed the *Sparks Headlight*. Charles Wallstab moved from Wadsworth to open his Wallstab Hotel on Harriman Avenue with a lunchroom, dining room, and bakery.

George Robison divided his 80-acre ranch into lots called the Robison Tract and sold them to new residents and businesses. Part of the Mary Wall Ranch on the western edge of Sparks that was not sold to the railroad became part of the New Town addition. The first house not in the Reserve was built by Ben Seymour in the Hibbard and McPhail tract.

Early church services were held in 1904 by Rev. Francis M. Willis of the Methodist Episcopal Church when he made trips on horseback and held services in cabins and farmhouses. Wadsworth churches followed their parishioners. Emmanuel First Baptist Church opened a temporary building in 1904 on the corner of Twelfth Street and Harriman Avenue. St. Paul's Episcopal Church opened in 1906. The first school building in Sparks was built on land on the County Road donated by Col. Nicholas C. Prater in 1905. Classes were held in temporary quarters in some of the early churches before the school was completed. The Masons and other fraternal organizations also moved to Sparks. In a short time, the new town had churches, schools, a railroad library, saloons, hotels, grocery and mercantile stores, a bank, restaurants, and other businesses.

Sparks was a railroad and company town for the next 50 years. However, when the Southern Pacific changed from steam engines to diesel engines, maintenance work done in the roundhouse and shops was discontinued. Many of the 1,200 people employed in the Reno-Sparks area were reassigned or transferred to other stations. By February 1956, notice was given that the Sparks roundhouse was to be razed. Some former railroad employees took advantage of Nevada's thriving

hospitality and gaming industry to find new employment. The Freeport Law, passed in 1949, which allowed manufacturers to store goods in the state tax-free for one year, brought warehousing to Sparks, and the state's right-to-work law helped lead to the creation of light manufacturing jobs.

Sparks, long known as the "Rail City," adopted the new slogan "It's Happening Here" in late 2009 to highlight its many activities. The Best in the West Nugget Rib Cook Off in Victorian Square started in the summer of 1989 and boasts that it is America's largest free rib festival. It brought more than 500,000 visitors to the Reno-Sparks area in 2009. Hot August Nights, featuring classic cars, brings people to Reno and Sparks each August. Sparks has had a Hometowne Christmas celebration for 30 years, with a tree-lighting ceremony and parade. People come to Santa's village at 39 North Marketplace in December and to farmers' markets during the summer. Artown, held during the entire month of July, brings art, dancing, theater, music, and cultural and history events to Reno and Sparks.

In 2016, Sparks was the fifth-largest city in Nevada, with an estimated population of 93,000 covering approximately 38 square miles. It has three high schools, three middle schools, and seven elementary schools, as well as two branches of the Washoe County Library. Fifty city parks are within the city limits, including the large Sparks Marina with its 80-acre lake, picnic areas, dog park, fishing and fish-cleaning stations, and a two-mile paved trail. The Golden Eagle Regional Park, completed in 2008, has 1.4 million square feet of artificial turf for softball, baseball, football, and soccer games.

The Sparks Heritage Foundation and Museum opened in the basement of Sparks City Hall in April 1985. In June 1995, the museum moved to the old Sparks Justice Court and public library building at 814 Victorian Avenue (originally Harriman Avenue and then B Street). The exhibits in the Sparks Museum and Cultural Center highlight the rich heritage and diversity of Sparks and the Truckee Meadows, fulfilling the museum's mission to preserve "the historical and cultural heritage of Sparks and the Truckee Meadows."

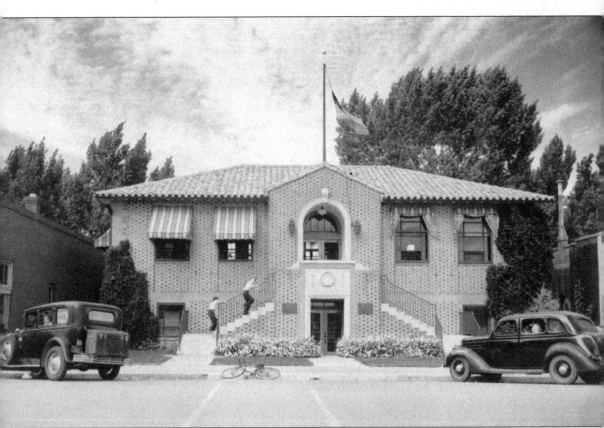

The first Sparks library was a railroad library that opened in 1905 and burned down in 1908. Railroad employees paid a fee to use this library. In 1929, the Nevada state legislature passed a bill to create county library systems. The Sparks Library was the first branch library to open in the Washoe County library system. Frederick DeLongchamps designed the building in the Mediterranean Revival style and contractors Rousch and Belz built it for $20,000. The Sparks Library was on the second floor, with a justice court and constable on the first floor. The library opened in January 1932 with 3,000 books, 48 magazine subscriptions, and 28 newspapers, and continued to serve the residents of Sparks until 1965 when a new library opened. (Sparks Museum.)

One

IN THE BEGINNING

Paiute and Washoe Indians camped along the Truckee River near Stone and Gates' Crossing for thousands of years, hunting, fishing, and gathering objects to use for clothing and shelter. Elisha Stevens led the first group of emigrants, the Stevens-Murphy party, through the Truckee Meadows in 1844. Stevens's route ran along the California Trail, through the Forty-Mile Desert (described on a Nevada historical marker as "a barren stretch of waterless alkali wasteland"), with no fresh water, little grass, and extremely hot temperatures in the summer.

When gold was discovered in California in 1848, many emigrants used this difficult and hazardous route to get to the California goldfields. If they survived the desert, they arrived at the Truckee River, with its fresh water and grass. H.H. Jamison built the first trading post, Jamison's Station, near Steamboat Creek (three miles southeast of present-day Sparks) in 1852. This area was part of Utah Territory until 1861, when Nevada Territory was formed.

George F. Stone and Charles C. Gates had a ferry crossing in 1857 and a toll bridge near Jamison's in 1860. Edward C. Ing and John Owens built another trading post nearby in the early 1860s. Stone and Gates' Crossing was a community with houses, stores, hotels, restaurants, and, in 1864, a school. When the post office opened, the community's name was changed to Glendale.

Glendale flourished until 1868, when the railroad's arrival in the valley led to the creation of Reno, and emigrants were no longer traveling through the community. Leonard C. and Abraham Savage built a toll road north of the Truckee River that eliminated some of the river crossings.

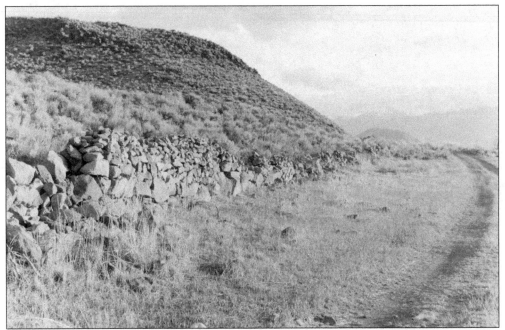

In 1852, H.H. Jamison may have had the first trading post in the Lower Truckee Canyon, located three miles southeast of what would later become Sparks and one mile from Stone and Gates' Crossing. This rock wall is thought to be the remains of Jamison's trading post. (NHS.)

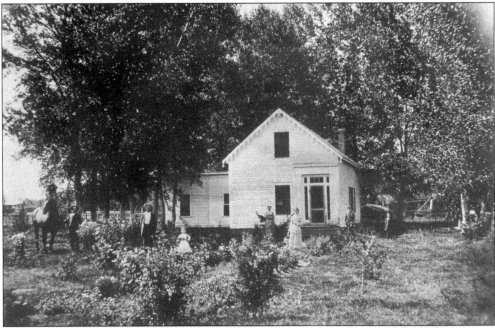

George and Susan Alt owned a ranch in Glendale near Stone and Gates' Crossing, about three and a half miles southeast of what is now Sparks. George Alt purchased land through school land warrant No. 3 in 1865. The ranch contained 258 acres of flat land near the Truckee River. The Alts raised Durham cattle and had orchards of apple, peach, cherry, and plum trees, along with large alfalfa fields. The Alt family and their farm hands are seen here in the 1890s. (NHS.)

In 1877, the Alts had 150 head of cattle and an orchard of 150 apple, 15 peach, 13 plum, and 12 cherry trees. By 1897, the *Reno Evening Gazette* reported the farm as being in a "grove of trees surrounded by flowers that makes the lover of the beautiful home-sick unless Dame Fortune has made it possible for him to own such a place." (NHS.)

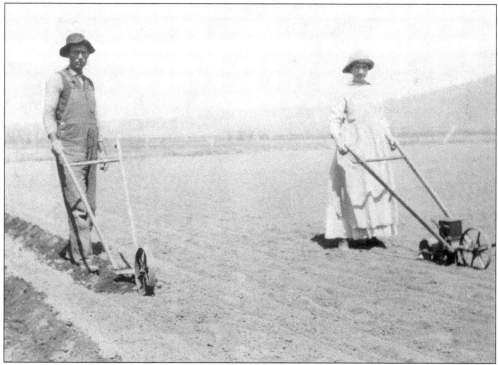

An article in an October 1950 *Nevada State Journal* described Glendale as "a charming place. Flourishing farms produced potatoes and vegetables for the Comstock, good grass and hay for cattle." Here, John and Pearl Kleppe seed their fields at their farm in Glendale in 1899. (NHS.)

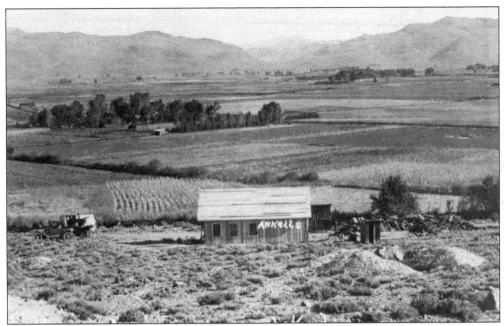

Alfalfa fields are shown near the Wedekind Mine in the 1920s. In the early days, Sparks was home to alfalfa fields where cattle and horses grazed. Real estate companies began selling the ranches and farms when the railroad came to town in 1904. In 1941, Sparks was described as being surrounded by farms on all but the west side. (NHS.)

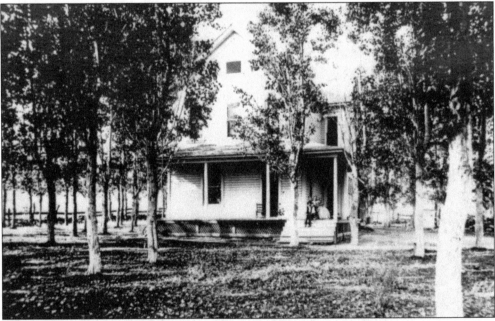

William H. Frazer came to the Truckee Meadows in 1873 and purchased 200 acres from William E. Vance in 1876. The Frazer Ranch was covered with sagebrush and rocks and was described as completely uncultivated, but became "one of the best ranches in the Truckee Meadows," according to the March 8, 1920, *Reno Evening Gazette*. Frazer planted 100 shade trees in 1880 and later built this house among the trees. (Sparks Museum.)

In 1903 or 1904, William H. Frazer sold all but 10 acres of his land and built this house near the Wedekind Mine. Frazer's wife, Isabel (Belle), became a charter member of the Emmanuel First Baptist Church in 1904 and was mother to 11 children. One son drowned in a ditch near the ranch, and another son drowned at Pyramid Lake in 1895. (Sparks Museum.)

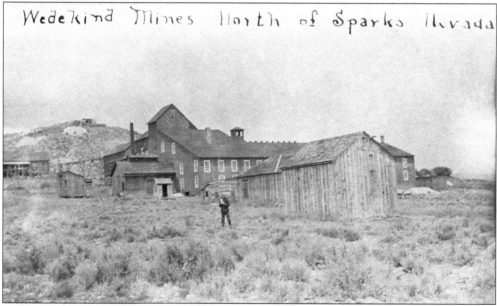

George H. Wedekind, a Reno piano tuner, found "a crumbling piece of yellow rock," as reported in the September 10, 1902, *Nevada State Journal*, two miles north of Sparks near the James Sullivan Ranch in 1896. The silver assayed at $600 to $1,200 per ton. John Sparks, who would later become governor of Nevada, paid Wedekind $155,000 for the Reno Star, Safeguard, and Precaution Mines and the mill site in 1901. Silver chloride, zinc, and gold were mined at the site. (Dick Dreiling.)

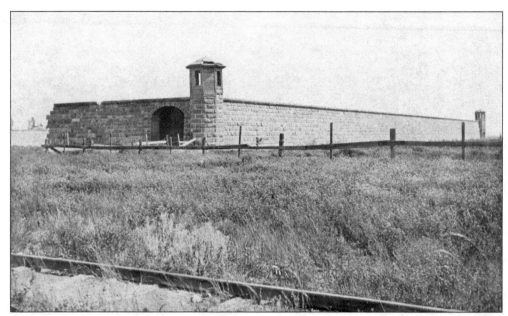

In 1874, the State of Nevada purchased 206 acres east of Reno, near the Truckee River and west of what would become Sparks, to build a prison. The plan was to move prisoners from the state prison in Carson City to this new facility. Construction started on the stone foundation and walls on August 29, 1874. In 1876, the Board of State Prison Commissioners refused to pay contractor S.F. Poole because of a problem with the watch towers. The stone walls remained in the empty fields. (Jerry Fenwick.)

Nevada's mentally ill were sent to the California Asylum in Stockton beginning in 1864. By 1881, the price to send these patients out of state was prohibitive. Nevada officials wanted to build an asylum in east Reno that would use the old stone foundation and stone walls constructed for the prison. The Nevada asylum, an F-shaped building, opened on July 1, 1882, with 148 patients. (Jerry Fenwick.)

Two

From Wadsworth to Sparks

Edward H. Harriman, president of the Southern Pacific Railroad, wanted to reroute the company's tracks from Sacramento through Nevada to Odgen, Utah, beginning in 1901. Land was bought in 1902, and the townsite was laid out in 1903. At the time, trains were the primary way both passengers and freight moved throughout the United States. By eliminating dangerous curves and steep grades, trains could transport more passengers and freight at a faster rate. Harriman found that land in Reno was too expensive, so he scouted four miles east of Reno for a new division point that would bypass Wadsworth, the existing division point. The Southern Pacific Railroad bought land on the Mary Wall and William Thomas Ranches for the new roundhouse, shops, and town. Newspaper headlines proclaimed: "Entire town to be moved." Wadsworth businesses and residents followed their customers and friends to this new unnamed town east of Reno.

Longtime railroad workers in Wadsworth were given the option to buy $1 lots on the Railroad Reserve west of the roundhouse. Houses had to be placed on the lots and inhabitable within 120 days of signing the deed. The first house moved from Wadsworth arrived on April 23, 1904, and workers continued moving the houses through 1905. Houses were split apart, put on flatcars, and hauled 30 miles to Sparks. Wadsworth businesses, churches, railroad unions, and social clubs followed. Business owners in Reno opened businesses in Sparks. The Surf Saloon was the first to open, in 1903, and the Bank of Sparks opened in January 1905. Schools were built, and eight teachers began educating almost 400 students in September 1904. Reno Power, Light and Water laid water pipes and provided electric service. An electric streetcar system was transporting people between Reno and Sparks by 1904. The area was given the name of Sparks in honor of popular Nevada governor John Sparks in March 1904. The city was incorporated in 1905.

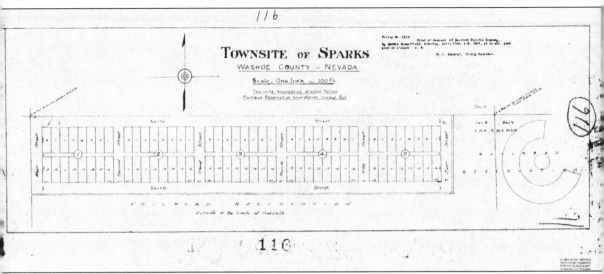

TOWNSITE OF SPARKS.
WASHOE COUNTY — NEVADA
Scale, One Inch = 100 Ft.

116

The Railroad Reserve is shown in map 116 (dated April 25, 1904) from the Washoe County Recorder's office. All of the deeds for lots in the Reserve followed this map. The lots were 50 feet by 140 feet. The Sparks City Council began to change street names in 1908, and officially recognized these changes in 1912. East Street on this map became Ninth Street, West Street became Fifteenth Street, South Street became A Street, and North Street became B Street. Today, houses on the Reserve can be found on A Street between Sixteenth Street and Rock Boulevard and between B Street and Prater Way. George Abbay's home address was 834 B Street, located on Block 3, Lot 15 (page 20). (WCR.)

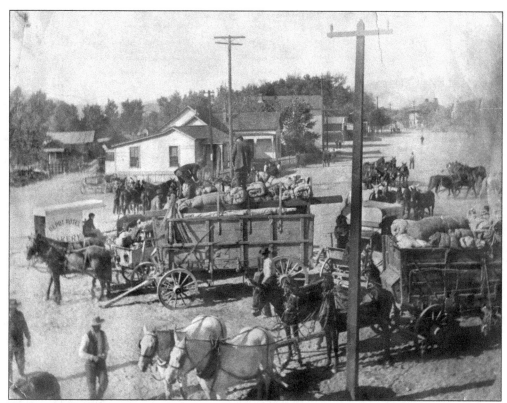

Wadsworth freight contractors are pictured loading up houses, workers' possessions, and everything that could be moved to take to the new town. Everything was taken to the Wadsworth rail yard before being loaded onto flatcars and boxcars. The September 1, 1944, *Nevada State Journal* described the living conditions of families in the midst of the move: "For days past the railroad employees of Wadsworth have been living with their families in barns and sheds and camping out under various conditions while their cherished homes have been carried off." (NHS.)

Construction in East Reno began in 1903. Ben Seymour built the first house in the Hibbard and McPhail "New Town" tract. Streets were graded, water pipes laid, and telephone poles erected. Paddy Reddy opened the first area business, the Surf Saloon, with a kitchen and dining room, in 1903. W.H. Patton began publishing the *Harriman Herald* newspaper in January 1904. (NHS.)

This Indenture, made the 10th day of May in the year of our Lord one thousand nine hundred
and four, between the Southern Pacific Company, a corporation created and existing under laws
of the State of Kentucky, the party of the first part, and George Abbay, of Washoe County,
Nevada, the party of the second part, Witnesseth:

That the said party of the first part, for and in consideration of the sum of One Dollar,
lawful money of the United States of America, to it in hand paid by the said party of the
second part, the receipt whereof is hereby acknowledged, does by these presents grant, bargain,
sell and convey unto the said party of the second part, and to his heirs and assigns all
that certain lot, piece or parcel of land situate in the town of Sparks, County of Washoe,
State of Nevada, particularly described as follows, to-wit:

Lot fifteen (15) of Block three (3) and as shown and delineated upon the map of said town
filed by the party of the first part in the office of the County Recorder of said County of
Washoe, on the 25th day of April 1, A. D. 1904, to which reference is hereby made.

Together with all and singular the tenaments, hereditaments and appurtenances thereunto be-
longing, or in anywise appertaining, and the reversion and reversions, remainder and remaind-
ers, rents, issues and profits thereof.

To have and to Hold, all and singular the said premises, together with the appurtenances,
unto the said party of the second part, and to his heirs and assigns forever.

This Conveyance is, nevertheless, made upon condition that the said party of the second part,
his executors, administrators, heirs or assigns, shall within 120 days from and after the date
hereof, construct or place upon the premises aforesaid a dwelling house and enter into and
occupy the same for dwelling purposes, and that at no time thereafter shall said premises or
any part thereof, be used for any purpose whatsoever other than dwelling purposes.

In the event of breach of either of the conditions aforesaid, all of the right and title
to said premises, hereby granted shall cease and determine, and said premises and the whole
thereof, and any and all improvements thereon, annexed to the realty, shall then and there
revert to, vest in and become the property of the party of the first part, its successors or as-
signs, and said party of the first part, its successors or assigns, shall then and there have
the right to enter upon and take and hold possession of said premises and all improvements
thereon, and to exclude therefrom the said party of the second part, his heirs, executors, ad-
ministrators or assigns, or any person claiming by, through or under either of them.

In Witness Whereof, the party of the first part has caused these presents to be signed by
its 4th Vice President and its corporate seal to be hereunto affixed and attested by its Secre-
tary or Assistant Secretary on the day and year first above written.

 (Corporate Seal) Southern Pacific Company
 By J. Kruttschnitt, 4th Vice president.
 Attest: G. T. Klink, Assistant Secretary.

(Correct as to description. William Hood, Chief Engineer.)
(Approved as to form. Wm. F. Herrin, Chief Counsel.)

 State of California,)
 SS:
 City and County of San Francisco.) On this tenth day of May A. D. 1904, before me, E. B.
Ryan, a Commissioner of Deeds for the State of Nevada, duly appointed, commissioned and sworn
residing in the City and County of San Francisco, and State of California, personally appeared

This deed signed by George Abbay is like all the deeds signed by railroad workers who paid $1 for a lot in the Railroad Reserve. It lists the lot number and block number that each employee received. A house had to be constructed or placed on the lot and occupied within 120 days from the date signed, and "no time thereafter shall said premises or any part thereof be used for any purpose whatsoever other than dwelling purposes." Deeds were signed by J. Kruttschnitt, fourth vice president of Southern Pacific. William Hood, Southern Pacific's chief engineer, swore that the description of the property was correct. Railroad employees who owned homes in Wadsworth were offered this deal. The "choice town lots" convinced Wadsworth employees to move. (WCR.)

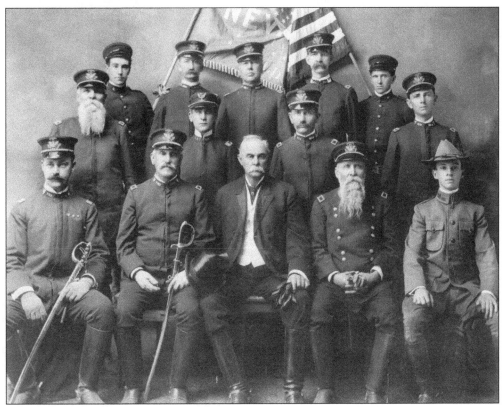

The new city was initially known as New Wadsworth, East Reno, Glendale, and Harriman. Railroad officials thought the names New Wadsworth and East Reno were confusing, and Edward H. Harriman did not want his name used. In 1904, someone suggested naming the new town after popular Nevada governor John Sparks. Sparks is shown here in the center of the first row with his military staff on Labor Day in 1906 in Reno. (NSLAR.)

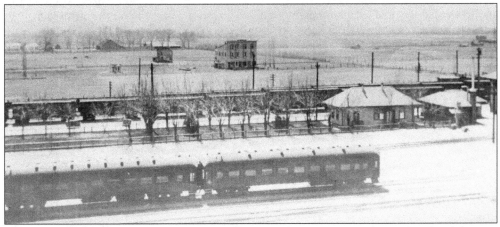

Stewart McKay, a hotel developer from Truckee, bought 40 acres on the south side of the new railroad complex and called it the McKay tract. McKay hoped that investors coming to purchase land would stay at his hotel or boardinghouse (pictured). McKay could not sell his property because Sparks developed north of the train tracks, not south, so his tract was cut off from the center of town. (Sparks Museum.)

Robison's Addition

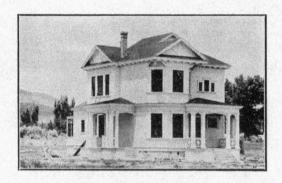

In 1890, George W. Robison bought 80 acres of farmland in what is now Sparks from William Chapman for $6,000. In 1902 and 1903, Robison laid out lots for businesses and residences in the new town. Streets within the Robison tract were 60 feet wide, with 24 lots to each block and 12 on each street. Business lots facing Harriman Avenue, or B Street, sold for $200 to $500 each, and residential lots sold for a minimum of $100. The lots were on the north side of Harriman Avenue, to the east of Eighth Street, north to the alley between E and F Streets, and west to Fifteenth Street. Advertisements stated, "Land is thoroughly drained. No malaria. Every lot is a choice lot, and the number is limited." (NHS.)

Developers G.W. Ingalls, Albert A. Hibbard, and Albert F. McPhail opened Deer Park in the New Town Tract on County Road in 1903. Deer Park, named for deer that were kept in a small enclosure, was an auto park for several years. The swimming pool opened on May 30, 1942. Children under 18 could swim for free every day from 1:00 p.m. to 5:00 p.m. Evening swimming began at 6:00 p.m. and cost 15¢. Towels could be rented for 5¢ each. (Sparks Museum.)

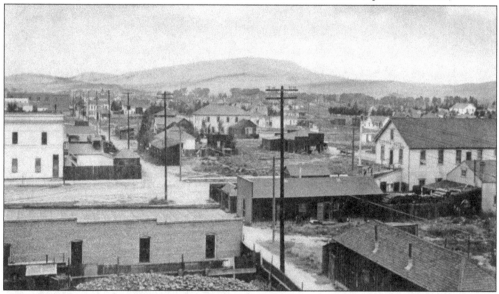

This photograph of Sparks was taken from the roof of the Wallstab Hotel looking east along Harriman Avenue between 1905 and 1910. The large two-story building on the right is the Europa Hotel at Seventh and C Streets, once owned by M. Gardella. The two-story building on the left is Robison Hall, located at Tenth Street and Harriman Avenue. The roundhouse is at the far end. (NHS.)

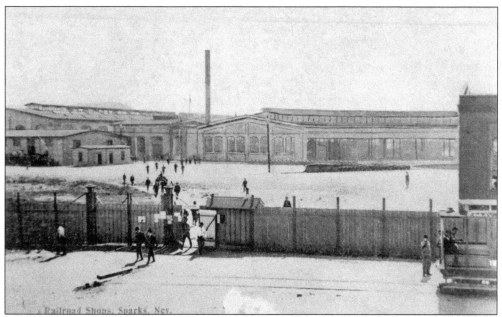

A fence built in 1905 completely encircled the three miles of rail yard. The high board fence was eight feet tall. A steam whistle, first blown on September 19, 1904, was manufactured in the Sparks shops and sounded at 8:00 a.m., noon, and 5:00 p.m. The August 3, 1904, edition of the *Reno Evening Gazette* reported that the machine shop, roundhouse, powerhouse, and office were completed by contractors Fabrion and Smith with over three million bricks used in their construction. (Sparks Museum.)

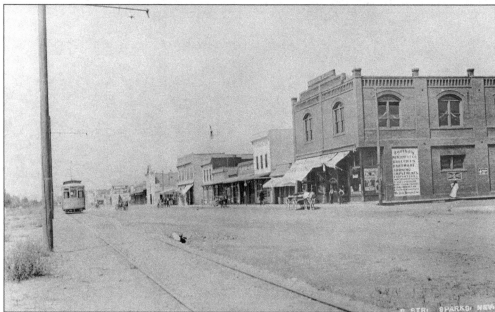

On November 29, 1903, the *Nevada State Journal* stated: "There are only fifty buildings in the new town at present and the majority of the people are living in box cars." Streetcars were running in 1904. George Robison constructed the Robison Mercantile Company building (pictured) in 1905. By 1950, B Street was thought to be the widest street in Nevada. (Jerry Fenwick.)

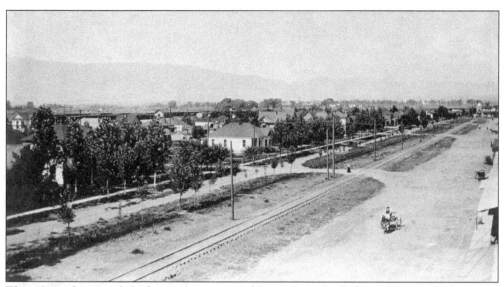

This 1910s photograph looks southwest toward Reno from the Robison Mercantile Company building and shows houses in the Railroad Reserve. The railroad planted the trees along B Street in 1908. Streetcars ran every 30 minutes from Commercial Row and Center Street in Reno to the roundhouse in Sparks. The first car left Reno at 6:30 a.m. and ran until 8:00 p.m. After 8:00 p.m., they ran every hour until midnight. (Jerry Fenwick.)

Howard C. Mulcahy, cashier at the Bank of Sparks, and later postmaster of Sparks, is shown standing in front of the bank in 1907. Richard Kirman and W.J. Harris of Reno, J.P. Raine of Sparks, N.C. Prater of Virginia City, and P.C. Bowles of San Francisco were listed as the original subscribers to its capital stock. The bank's incorporation papers were filed on September 20, 1904. Christopher Walker was thought to have been the first depositor. (Jerry Fenwick.)

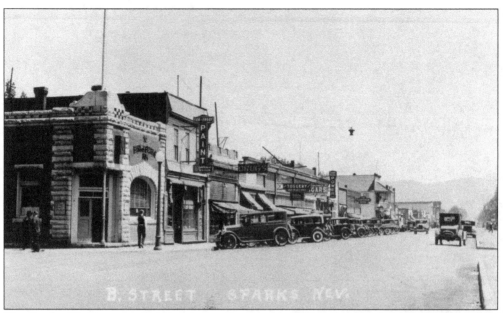

The Bank of Sparks opened on B Street on January 16, 1905, with office hours from 9:00 a.m. to noon and 1:00 p.m. to 3:00 p.m. William McMillan was the first cashier. The January 17, 1905, *Nevada State Journal* reported that, "while the building is not very large, yet the outside appearance is neat and attractive. It will meet the demands of the people of Sparks for the present and has ample capital to insure its permanent success." (Sparks Museum.)

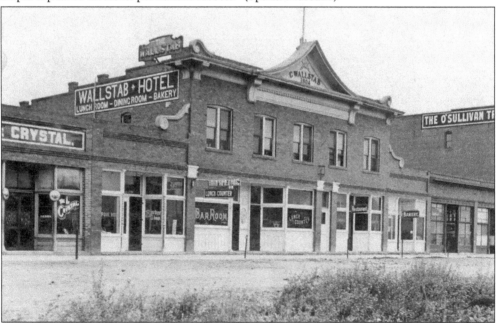

Herbert Kronnick designed the Wallstab Hotel for Charles Wallstab in 1904. Wallstab moved from Wadsworth to open this first hotel in Sparks. It was located in the O'Sullivan Tract at 624 B Street. The hotel had a pool hall, saloon, lunch counter, and restaurant on the first floor and 27 guest rooms on the upper floor. It became the Lincoln Hotel in 1920, after Frank Gardella and Frank Passutti purchased it. (NHS.)

The Davis Hotel, located at 830 B Street, was built by S.L. Williams of Sparks and owned by Russell Davis; it opened on December 15, 1930. Melita Ray Romaine bought the Davis Hotel and Coffee Shop in October 1940. Later, Gerald and Thelma Corron owned and managed the hotel before selling it to Thelma L. Gabbard. Gabbard renamed the hotel for her father, George A. Abbay. George Tonelli purchased the hotel from Gabbard in 1977. (Sparks Museum.)

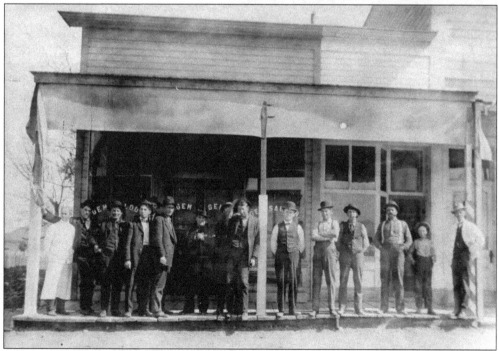

An article in the January 1, 1905, *Nevada State Journal* reported: "Naturally, like all new towns, Sparks possesses its due proportion of saloons." Teddy Lehr was the proprietor when the Gem Saloon opened in 1907. The volunteer fire department was called to the property in December 1907 to extinguish a roof fire. Lehr thanked the volunteers for their fine work. (Sparks Museum.)

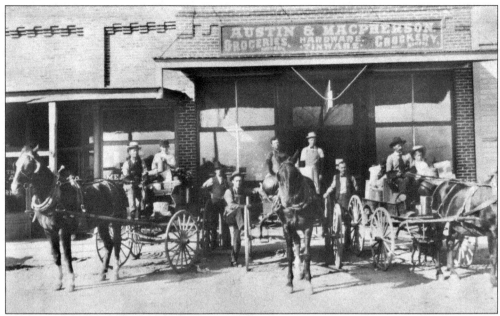

Austin & MacPherson, a grocery and general merchandise store in Wadsworth, opened in a new brick building in Sparks in January 1904. The store employed six men and had two delivery wagons, and sold groceries, hardware, tin ware, crockery, paint, and nails. Walter MacPherson bought the store when Eugene Austin died in 1912. MacPherson later joined with Roy Robison to open a hardware business, Robison and MacPherson, that continued until 1944. (NHS.)

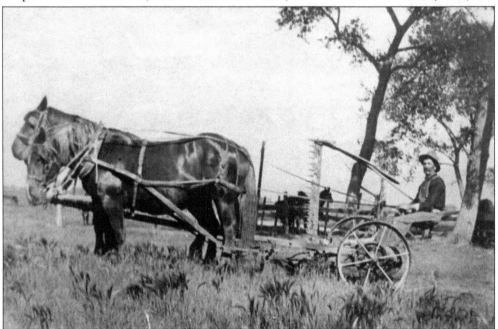

Tony Semenza (known as Anthony Semenza), a native of Italy, was a railroad truck repairer in 1910, when he lived at 1338 A Street with his wife, Maria, and their children Lawrence, Anita, and Albert. Antonio Semenza is shown at his ranch in the Glendale district of Sparks in 1914 or 1915. (Sparks Museum.)

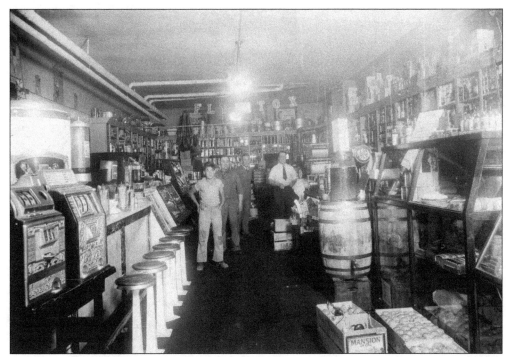

Tony Semenza opened the Semenza Grocery, Fountain and Confectionary in 1911 at 1038 B Street. Semenza sold the store to Guido Picchi, Serafino Donati, and Louie Giovanonnini in 1927. Picchi stated in an article in the *Reno Evening Gazette* in November 1956 that "the store use to have what the other fellow didn't or couldn't get and specialized in Italian foods." Picchi sold the store to Bob Clarkson in 1959. It is pictured here in the 1940s. (Sparks Museum.)

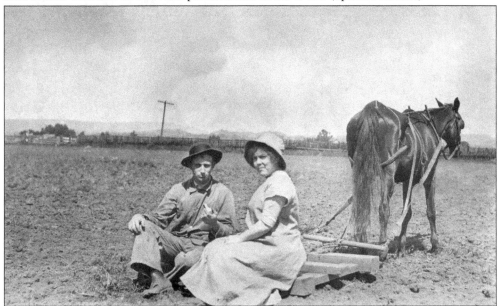

In 1917, Frank H. Webster came to Sparks with his wife, Bessie, to work as a brakeman for the railroad. Frank and Bessie are pictured on a horse-drawn tiller probably in a lot near their home, which was located at 1230 E Street. (NHS.)

Belle Hawkins (center) is shown in 1915 in front of her home at 1325 B Street with her children James, John, Ellen, and Susan. Belle's husband, James Henry Hawkins, a butcher, died in July 1908. Ernest and Grace Warner lived here during the 1930s and 1940s. (NHS.)

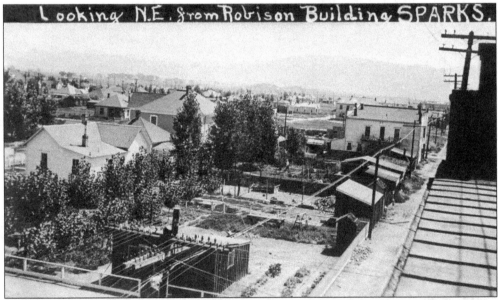

This photograph, taken from the top of the Robison Mercantile Company building, looks northeast toward C Street. Most residents had vegetable gardens with small orchards, outbuildings for storage, and outhouses in their backyard. Many photographs from the early years of Sparks appear smoky or smoggy because of the smoke from the rail yard. (Jerry Fenwick.)

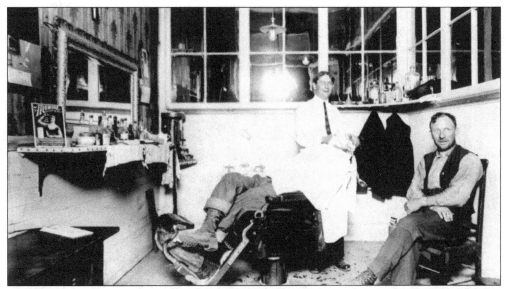

The B Street Barber Shop was located at 908 B Street. In August 1922, the barbershop advertised for a barber who "must be a good worker." By 1939, the shop had become the Golden Rule Company, which offered "Ladies dresses; latest styles and colors" for $2.29. It became a barbershop again in 1949, and in 1970, Darold "Shorty" Diehl ran Shorty's Barber Shop here. (Sparks Museum.)

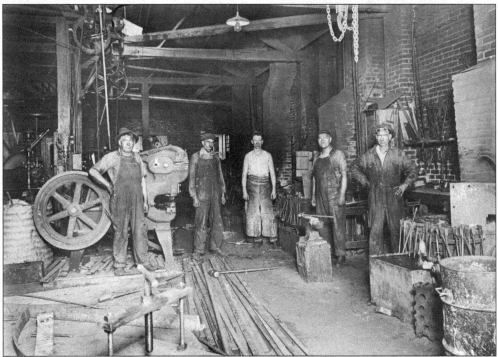

Horatio "Mac" McCollum, father of Oral McCollum, is thought to have had the first blacksmith shop in Sparks, at Ninth and C Streets. From left to right are Ed Cassinova, John Ginochio, Rex Steel, Mac McCollum at the anvil, and Lou Denevi in 1917. The equipment shown includes a drill press (left background), a friction belt drive auto hammer with shear blade bolted in (left), a quenching tank and hardy block (lower right), and a winch and chain (ceiling). (NHS.)

Johnny Smith moved the two-story house on the left, located at 1129 B Street, from Wadsworth to Sparks in 1904. His wife sold it to Rose Bartlett, a dressmaker, in April 1914. This 1914 photograph shows four unidentified men in the street. (Sparks Museum.)

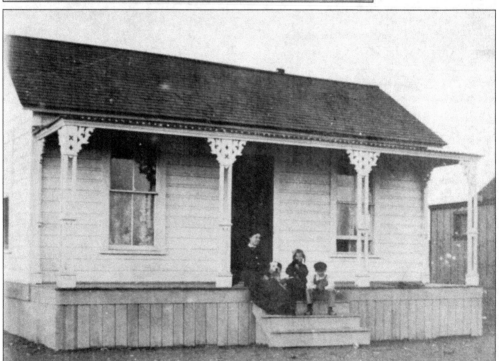

Eugene Austin moved his Wadsworth home to 938 E Street in the early 1900s. Austin was one of the owners of the general merchandise store Austin & MacPherson. Mary Austin, seen here with her children, lived in this house for many years after the death of her husband in 1912. Her youngest daughter, Helen, was married here in June 1920. (Sparks Museum.)

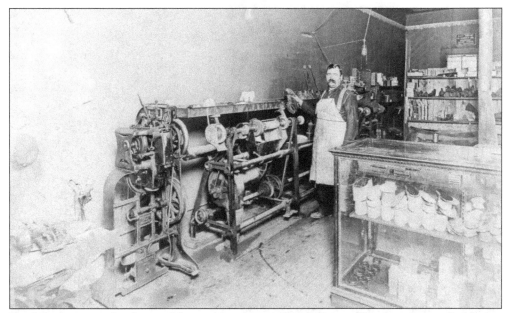

Frank Lipera opened a shoe and boot repair shop at 1012 B Street. The shop, later called Lipera & Son, sold sporting goods and work clothes along with Wolverine shoes. The City of Sparks leased the Lipera building on November 15, 1944, for use as a teenage recreation center, or canteen. With help from the city, a canteen committee took over the lease on November 28, 1944. (Sparks Museum.)

Louis "Ed" Allard, a coppersmith and pipefitter for the Southern Pacific from 1921 to 1948, opened a plumbing shop on B Street during the 1911 railroad strike. Allard moved to Sparks in 1907 and was a Sparks city councilman from 1951 to 1955. (Sparks Museum.)

Christian Christensen had a butcher shop in Sparks in 1904 and later bought 80 acres between Glendale and the railroad tracks on Stanford Way and Dermody Way. He operated Christensen Dairy, perhaps the first dairy in Sparks, until 1942. Agnes Risley Elementary School is named for Christensen's daughter Agnes, a popular Sparks teacher and librarian. The barn at Christensen Dairy is seen here. (Sparks Museum.)

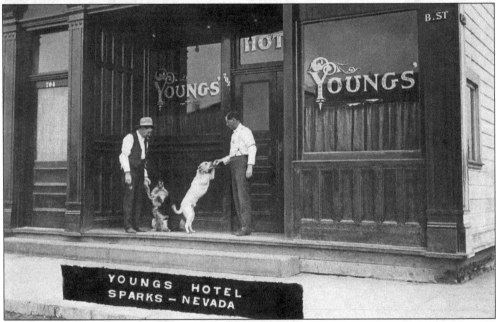

Brothers C.G. "George" and Frank A. Young were proprietors of Youngs' Hotel, which had a grill and dining room, in 1907. Sparks City Council outlawed drinking in a buggy at the curb of a saloon in 1907, forcing customers to go into saloons for their drinks. Youngs' Hotel had a bar and gambling games. (Jerry Fenwick.)

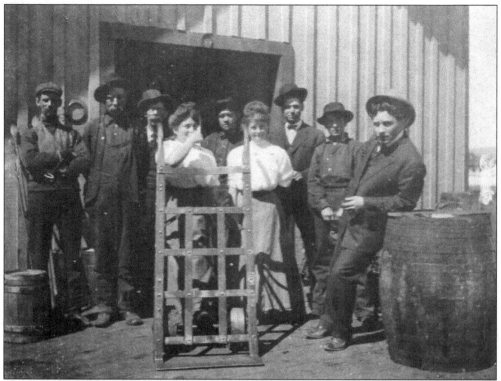

Daniel "D.J." Fodrin and his brother J.P. "Pete" Fodrin came to Sparks in the early 1900s to work for Southern Pacific. Daniel was the freight and passenger agent, and Pete was the freight office clerk in 1907. Gov. Grant Sawyer presented Daniel with a certificate for "the longest continuous residency in Sparks" in 1964. Daniel served as mayor of Sparks from 1939 to 1947 and again from 1951 to 1953. (Sparks Museum.)

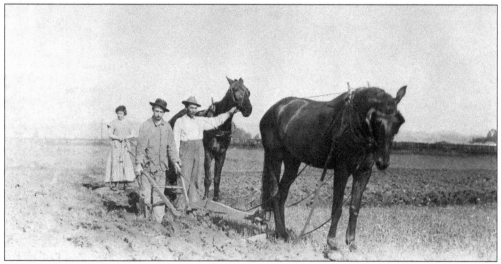

Frank and Bessie Webster are shown tilling their land near their home. Two or three crops of alfalfa could be harvested each year in the Truckee Meadows. Onions, cabbages, and potatoes were also grown in the area. Crops were irrigated via ditches that fed from the nearby Truckee River. (NHS.)

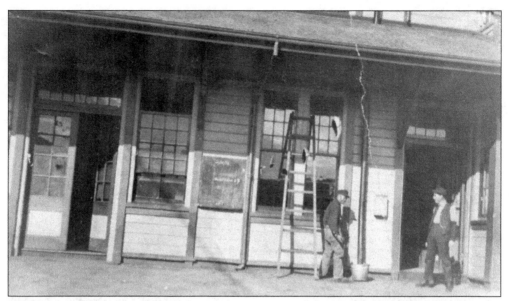

Wah Lee, janitor for the railroad for over 34 years, is on the left near the ladder, and George Abbay Jr., yardmaster, is on the right in front of the Southern Pacific Manifest Office. All of the freight or cargo coming to the Sparks yards was verified according to owner and location in this office. Freight would be transferred to trains going to other locations or stored in the yard awaiting transfer. (Sparks Museum.)

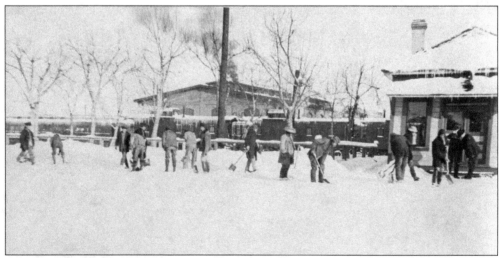

Chinese workers are shown shoveling snow in front of the Southern Pacific Hospital on January 3, 1916. Chinese men worked as janitors, truckers, engine wipers, sweepers, supply men, machinists, and laborers. Sparks's railroad Chinatown, located east of the rail yards and south of B Street, was destroyed by fire on November 11, 1926. Wah Lee, shown in the photograph above, died soon after the fire at age 69. (Sparks Museum.)

Robert Baker, dressed in clothing from the early 1900s, was chairman of the Sparks three-day 40th anniversary celebration held on September 2–4, 1944. Events included an "old-timer" parade, softball and hardball games, a barbeque, a street dance held on B Street, a beard-growing contest, and much more. (Sparks Museum.)

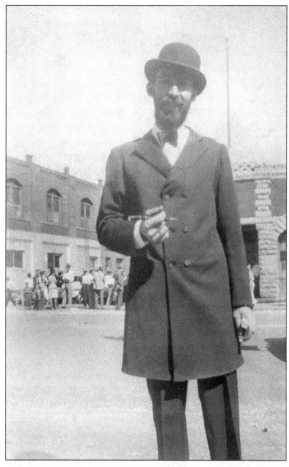

A Labor Day parade was due to start at 9:00 a.m. on September 5, 1910, but did not begin until two hours later, when the queen, Nellie Sullivan, emerged from the Sparks Grammar and High School. According to the *Nevada State Journal*, Sullivan wore a "satin duchess dress piped with gold braid" that signified the state's mining industry. The parade's grand marshal was Jack Murray. Chief A.A. Burke of the Reno Police Department and Chief Hugh K. Morrison of the Sparks Police Department marched with their officers, followed by many railroad unions. (Dick Dreiling.)

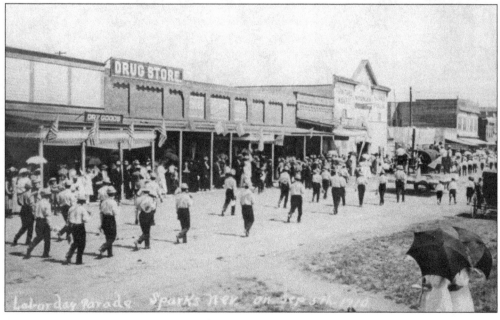

Rose and Frank Lipera, along with their daughter Mary and son Mid, pose in their horse-drawn cart soon after arriving from Italy in 1905. Frank Lipera worked in a boot and shoe repair shop and had lived in Sparks for 40 years at the time of his death in 1945. (Sparks Museum.)

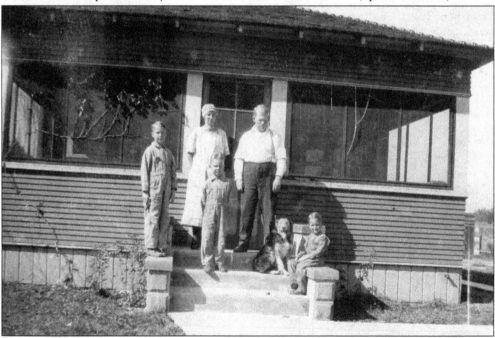

Harry Pettengill worked for Southern Pacific from 1906 to 1946. In 1920, he was a brakeman. Pettengill is shown with his wife, Laura, and their children Conrad, Alden, and Savior at their home at 429 Fifteenth Street. Laura was a member of the Ladies' Auxiliary of the Railroad Trainmen. (Sparks Museum.)

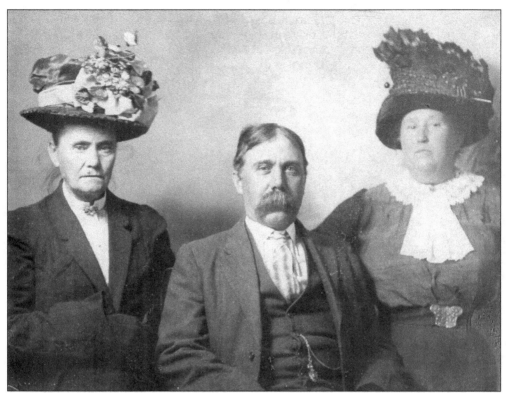

James Devine and his wife, Mary (right), are shown in the early 1900s. The family lived at 346 Tenth Street. Devine was appointed chief of police in 1913 and won the election for justice of the peace in 1914. On February 6, 1915, he married Harry DeLisle and Frances Heinz in his first marriage ceremony as justice of the peace. (Sparks Museum.)

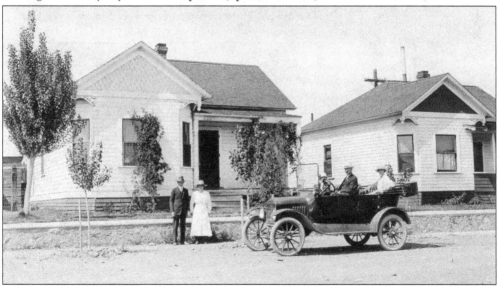

John L. Seifert and his wife, Catherine, are pictured in a car in front of Frank and Bessie Webster's house on C Street in the 1910s. Seifert, a brakeman for 50 years, retired from Southern Pacific in 1951. He was a member of the Brotherhood of Railway Trainmen. (Jerry Fenwick.)

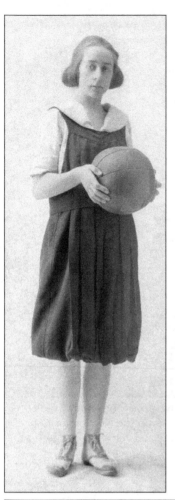

Elsie Christensen, daughter of Christian and Katherine Christensen, is shown here when she played basketball for Sparks High School in the early 1920s. The team, known as the "Streamliners," played teams throughout northern Nevada including Reno, Carson City, Virginia City, Fallon, Dayton, and Winnemucca. In 1920, the Sparks girls' team beat Dayton 40-8. (Sparks Museum.)

Revada Sales Company sold a bright red fire truck to the City of Sparks in March 1917. The fire truck had "a triple combination chemical and pumping engine and the automobile motor is a 75-horsepower affair," as reported in the March 4, 1917, edition of the *Nevada State Journal*. The fire truck was featured in the 1919 Sparks Labor Day parade along with a hand-drawn hose cart. (NHS.)

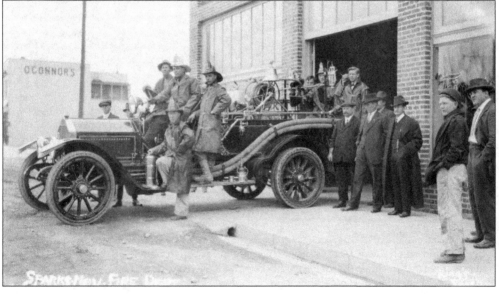

Three

PLANES, TRAINS, CARS, AND HORSES

Sparks was a railroad town from its beginnings in 1903–1904 until the mid-1950s. As a division point for the railroad, Sparks had crews going east 500 miles to Ogden, Utah, and west 150 miles to Sacramento. The Southern Pacific Railroad was the city's major employer and provided a stable payroll. Railway workers maintained, rebuilt, and serviced steam engines with wood-burning boilers, then progressed to huge cab-in-front locomotives. The roundhouse and shops were enlarged and modernized to repair, rebuild, and service all makes and sizes of engines.

US Highway 40, as part of the Lincoln and Victory Highways, was first routed from Fourth Street in Reno on County Road/Prater Way to Fifteenth Street in Sparks, then turned south to connect with B Street and continued through Sparks. In 1934, the route was straightened to connect B Street directly to County Road at a "Y" intersection, bypassing most of Prater Way.

Airplanes began landing in Sparks as early as 1919, when the Victory Loan Flying Circus airplanes took off from the rail yards in April and a transcontinental air race pilot landed near Vista in October. In 1937, Ted Morrill opened the Vista Air Field on County Road four miles east of Sparks to train pilots. During World War II, Vista Air Field was a Civil Air Patrol base. In 1946, the Sparks Airpark opened on Pyramid Lake Road, where the Greenbrae Terrace Shopping Center is today, for pilot training and private airplane storage.

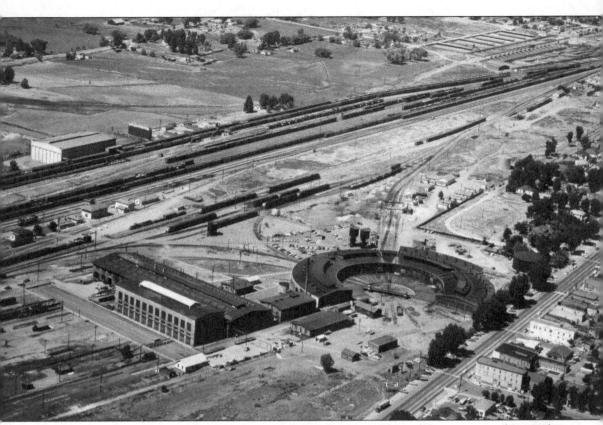

Southern Pacific laid the foundations for the roundhouse, machine shop, car repair shop, and locomotive boiler repair shop in late 1903. The roundhouse, which opened in 1904, had 40 stalls and was said to be the largest roundhouse west of Chicago. It accommodated 90 to 100 engines daily and could house 40 engines at one time. Locomotives were repaired or rebuilt in the large back shop, and the yard had over 30 miles of track. A 100-foot turntable was installed in 1911 and enlarged in 1928 (to 120 feet) to become the largest turntable in Nevada. The 120-foot turntable turned the large cab-forwards and moved engines in and out of the roundhouse and to different tracks or changed their direction of travel. Newspapers described the Sparks rail yards as "miles of side tracks and hundreds of switches." The machine shops measured 450 feet long by 120 feet wide. There were store rooms, a powerhouse, engine rooms, a foundry, and a car-building plant. A large erecting shop opened in 1944. Electricity was supplied to all of the buildings from a steam turbine electrical generating plant. (Sparks Museum.)

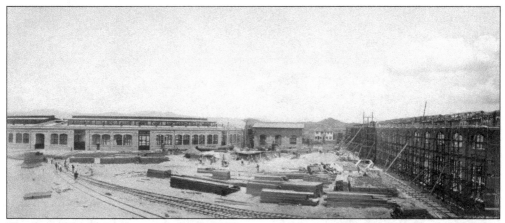

The site of Sparks and its railroad buildings was mostly swampland when Southern Pacific purchased it in 1901 to house the roundhouse and shops. It took six months to fill and level the land with rocks and dirt taken from Poor's Ranch, then dirt from near Vista, and finally rocks from near Salva (now Patrick) east of Sparks. Construction on the roundhouse and shops began in 1902 and was completed in 1904. (Jerry Fenwick.)

Minor repairs were made with repair-in-place (RIP) track. Carpenter shops, added to the Sparks yard in 1906, were located nearby. By 1904, the rail yards had over 32 miles of track with 107 switches. Eleven side tracks were added to the Sparks yard in 1907 to accommodate increased freight traffic and congestion. (Sparks Museum.)

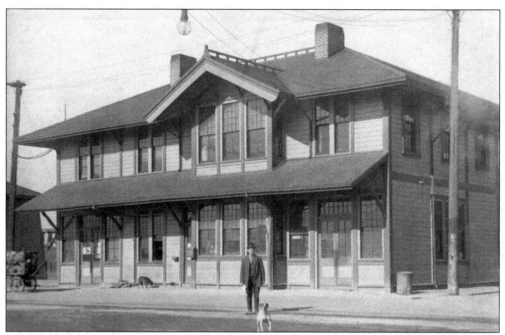

The yard office, built in Wadsworth around 1868, was moved in pieces to Sparks in 1903–1904 along with the assistant superintendent's office, the dispatchers' quarters, and parts of the yard fence. By December 1904, all machinists, blacksmiths and their helpers, and boilermakers had relocated to Sparks. The freight house and station on the west end of the yard opened on October 5, 1905. The Southern Pacific hospital and library opened in 1905. An employee clubhouse opened at B and Ninth Streets in 1910. (Sparks Museum.)

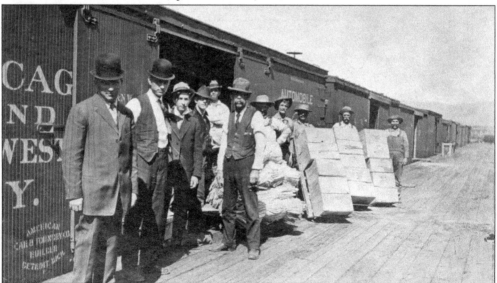

The freight-loading platform gang is shown here in the early 1910s. The freight and passenger depots were at the west end of the rail yard. The platform gang loaded and unloaded freight, and the freight agent kept track of the accounting. In 1907, the freight transactions accounting system, which was maintained in Ogden, was transferred to Sparks, and the railroad hired more freight clerks. (Sparks Museum.)

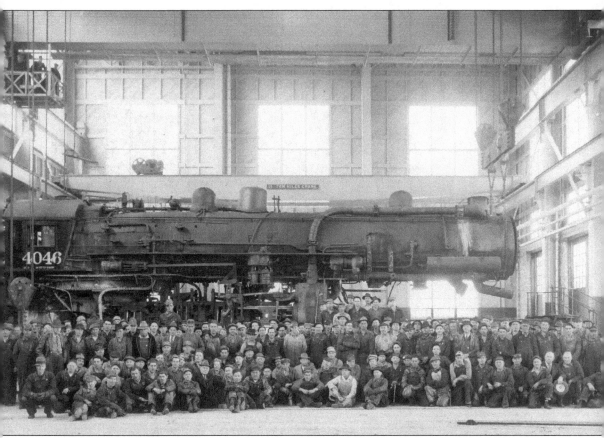

Engine 4046 was the first to be lifted by the new electric crane in the new erecting shop on February 9, 1944. J.C. Hanssen, master mechanic for Southern Pacific's Salt Lake Division, reported that 274 permanent positions would be added in the new and enlarged shops. Dormitory housing was built for these new employees, with rent set at $3.50 per week, or employees could pay $36.50 per month for a home. On March 31, 1944, the *Reno Gazette Journal* reported: "Railroad officials point out that the investment in the new erecting shop is a permanent one, and new workers should become permanent residents of Sparks and Reno." (NSLAR.)

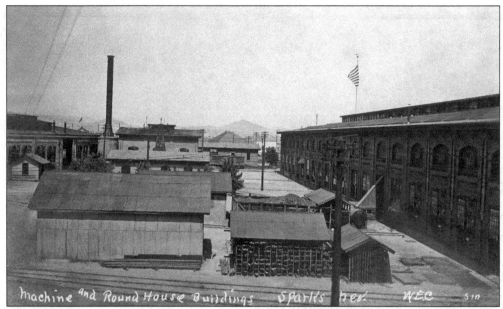

Frank Roehr, car shop foreman, wrote an article for the *Southern Pacific Bulletin* in August 1923 titled, "Sparks 'Great Big Little Car Building Plant,' " which said the car shops were a great inspection and repair point. He wrote that the freight equipment on the Southern Pacific was in first-class shape. The Sparks carshop was 1,000 by 150 feet, with 10 stalls. The machine and boiler shops were smaller, at 465 by 185 feet each. (Jerry Fenwick.)

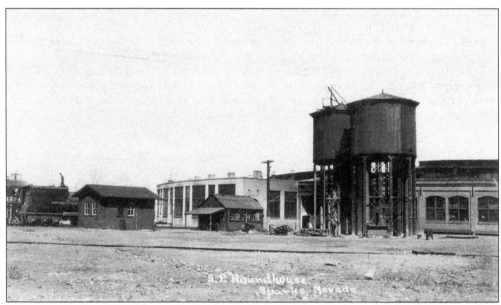

The roundhouse was enlarged twice so that it could overhaul larger locomotives. At its largest, the roundhouse had 22 stalls that were 90 feet long, 9 stalls that were 105 feet long, and 9 stalls that were 150 feet long. The crews in Sparks were able to handle both steam and diesel engines. (Jerry Fenwick.)

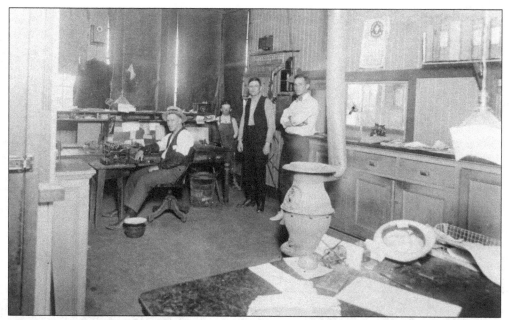

H.P. Davis (sitting at the desk) is shown with two unidentified men in the yard office in 1917. Sparks was at the end of the Sacramento Division, which ran over the Sierra to Sparks, and at the beginning of the Salt Lake Division, which ran 539.1 miles from Sparks to Ogden. J.F. Shaughnessy was the first assistant superintendent in 1904. Fred C. Smith, George Geiger, and D.E. Canady were the assistant superintendents in charge of the Sparks yards in 1915. (Sparks Museum.)

Pictured from left to right standing in the rail yard in 1924 are Frank Roehr, general car foreman; Henry Payne, clerk; John Burke, chief clerk; and Leland Fife, foreman. Payne was chief timekeeper for the railroad and secretary of the Sparks Federation of Labor in 1920. Fife worked as the assistant master mechanic in 1931 and transferred to San Joaquin, California, as a master mechanic in 1937. (Sparks Museum.)

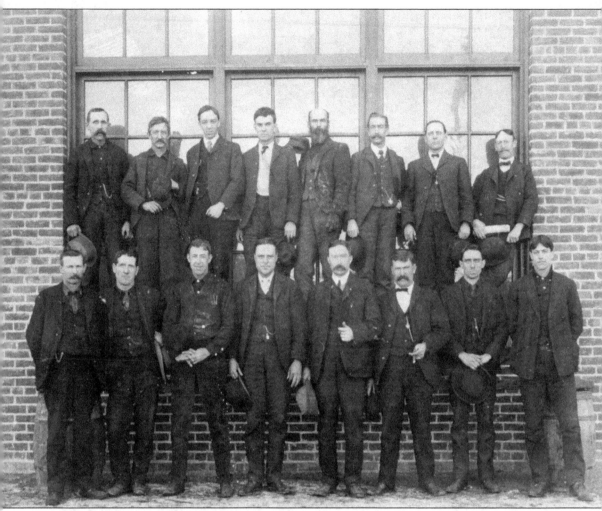

Sixteen shop foremen were needed to manage the large Sparks rail yard in 1905. Pictured here are, from left to right, (first row) R.H. Davis, boiler foreman; J.C. Carrigan, erecting foreman, W.R. Ashby, roundhouse foreman; F.C. Kerin, assistant master mechanic; G.F. Goble, general foreman; W.J. McEnerny, car foreman; C.V. Cheney, blacksmith foreman, and M.J. Hier, assistant boiler foreman; (second row) J. Larson, carpenter foreman; J.H. Sullivan, pipe foreman; C. Thorburn, storekeeper; C.W. Dresser, assistant roundhouse foreman; J.M. Blanchard, painter foreman; H.L. Luttrell, general foreman's clerk; J.A. Breen, machine foreman; and W.C. Wilson, gallery foreman. (NHS.)

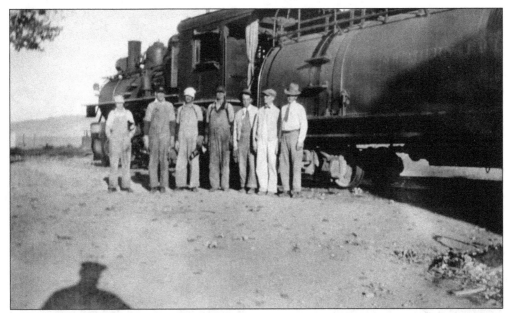

The train crew pictured here in the 1920s includes, from left to right: Roy Eckley, E.I. Wagner, ? Goda, ? Albertson, Ernest R. Wonke, John Dunn, and Frank Gates. Gates, an assistant storekeeper, moved from Wadsworth in September 1904. Gates was a brakeman in 1908 and a conductor in 1915. Wonke belonged to the Brotherhood of Locomotive Engineers. Dunn was a foreman in 1920. Wagner was a fireman in 1920. Eckley was an apprentice machinist in 1920 at age 16. (Sparks Museum.)

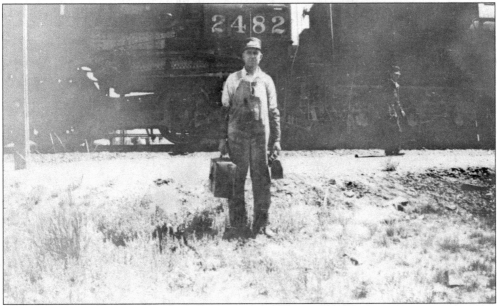

Christopher C. Walker moved with the railroad from Wadsworth to Sparks in 1904. Walker worked for 51 continuous years with Southern Pacific, starting as a fireman and retiring as an engineer. At the end of his career, he was an engineer on the *City of San Francisco*. Walker is shown heading home with his grip and lunch pail. As an engineer, Walker traveled from Sparks to Carlin, staying the night before returning to Sparks. The grip was his overnight carryall. (Pat Ferraro Klos.)

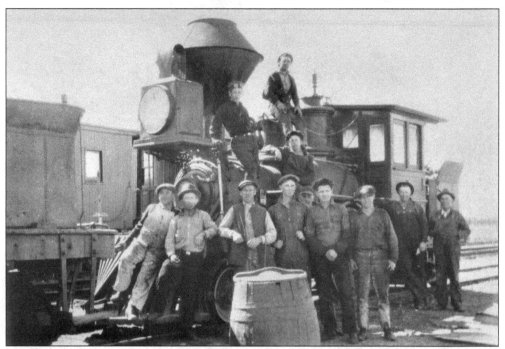

In 1906, a fast-mail train traveling 30 miles per hour ran into a switch engine. The switch engine crew, standing at the side of the engine, escaped injury. The *Reno Evening Gazette* stated that "the accident was probably caused through carelessness in leaving the switch open and allowing the fast mail to run from the main line into the siding where the switch engine was standing." (NHS.)

This 1939 image shows an inside view of the roundhouse and turntable. The turntable (in the center) would move engines to their assigned stalls for service or repair. Before the engines went into the roundhouse, boilermakers inspected the fireboxes and machinists examined the springs and brake rigging. The shop foreman kept track of the "ready time" of each locomotive. Engine 1154 is shown with its coal tender. (NDOT.)

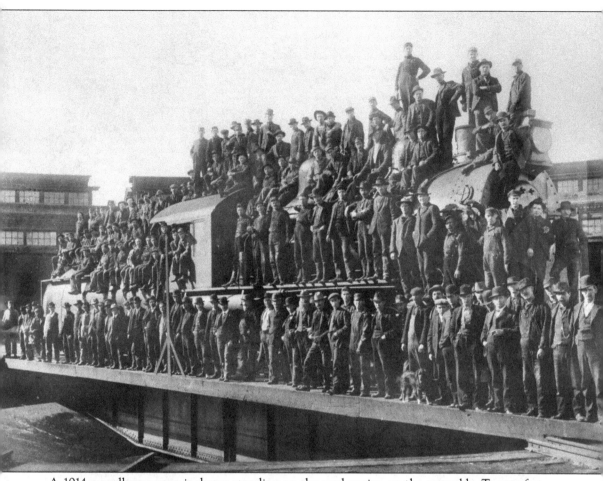

A 1914 roundhouse crew is shown standing on the yard engine on the turntable. Twenty feet were added to the original turntable in 1911 so it could turn larger locomotives. On March 29, 1911, the *Reno Evening Gazette* described the process for building the new turntable: "the method being pursued is to excavate the outside wall of the old turntable pit and cut out only three or four stalls at a time." (NHS.)

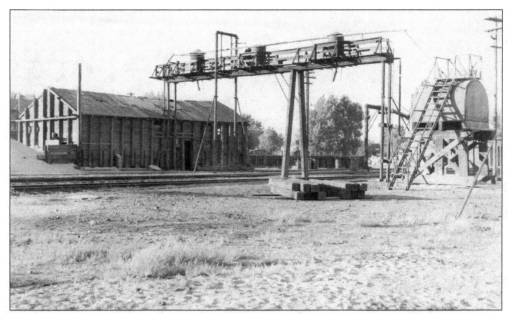

The sand bridge is shown in the yards with the sand tower and sand house. The sand house, which measured approximately 25 by 50 feet, was wood framed. A September 9, 1904, *Nevada State Journal* article reported that a "pneumatic apparatus for forcing the sand from the house to the sand boxes of the engine" was installed. Wet or unprocessed sand was stored on one side, and dried sand was stored on the other. An oven or kiln was used to dry the sand, which was then piped to the sand tower to be put in the locomotive's sand box (or dome). Sand was used to provide traction on wet tracks. (Sparks Museum.)

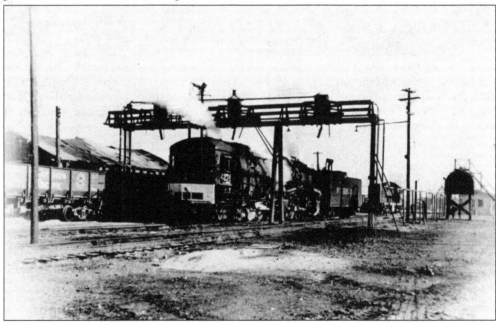

Engine 4274 is getting water in the rail yard. A hostler and his helper would fill the locomotive sand box and make sure the tender had water and fuel oil before the locomotive went to the roundhouse for repair or service. (Sparks Museum.)

The water and fuel tanks are shown here in the 1950s. Tanks were usually 16 to 30 feet in diameter and could hold 20,000 to 80,000 gallons. Sparks had two tanks that held 66,000 gallons each. Water tanks were usually placed near the roundhouse. After 1912, fuel tanks held bunker oil. (Sparks Museum.)

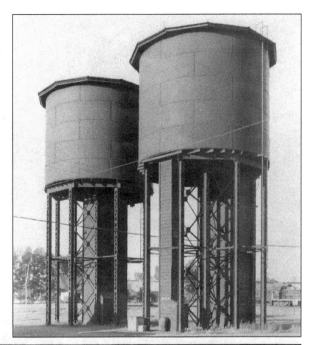

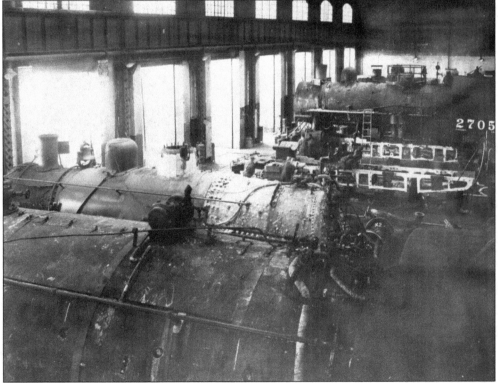

Southern Pacific locomotive No. 2705, engine type 2-8-0, is being repaired in the roundhouse in 1944. Shown are engines in the back shop. Engines were taken apart and stripped down to the bare frame. Cranes moved the firebox and boiler to the boiler shop, and flues were removed. After all this, the engine was put back together. (Sparks Museum.)

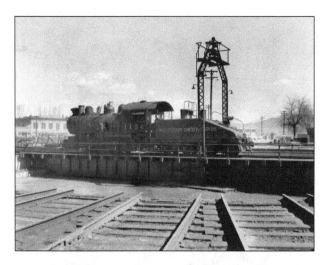

Southern Pacific locomotive No. 1154 and its coal tender are shown parked on the roundhouse turntable in the late 1930s. A switch engine, or goat, would move engines around the yard and back shops or was used in freight yards for local freight assignments. Switch engines were often rebuilt from old locomotives. The roundhouse was enlarged in 1930 by removing walls on the western side of eight of the stalls. The larger roundhouse allowed for maintenance of the larger Mallet locomotives. (Sparks Museum.)

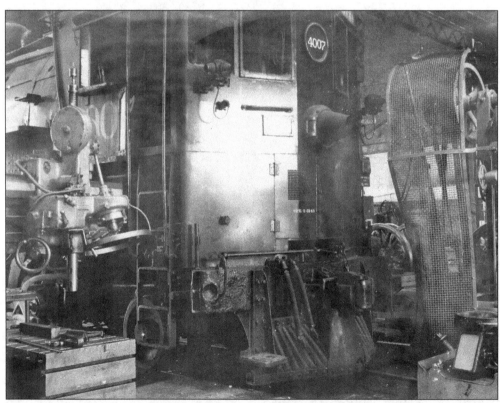

This cab-in-front engine, No. 4007, was built in 1909 by Baldwin as a class AC 1 (articulated-consolidation) locomotive and later renovated to a cab-in-front locomotive AC7. It is pictured in the roundhouse in 1944. These powerful locomotives pulled heavy freight and passenger trains over the Sierra from Sacramento. Crews had trouble with the 2-8-8-2 MC-1 Mallets because of exhaust fumes when going through many snow sheds and tunnels. Railroad design engineers designed the cab-forward or cab-in-front mallets to solve the exhaust problems. (Sparks Museum.)

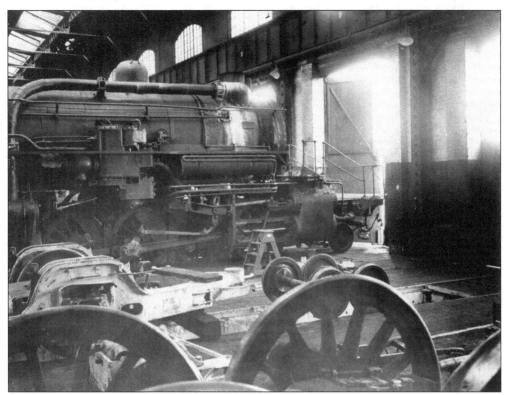

Shown is the back end of engine No. 4007 in the roundhouse in 1944, possibly going through monthly inspection and maintenance required by the federal Locomotive Inspection Law of 1911. Roundhouse crews performed extensive inspection and maintenance of boilers, brake and signal equipment, steam gauges, and safety valves. (Sparks Museum.)

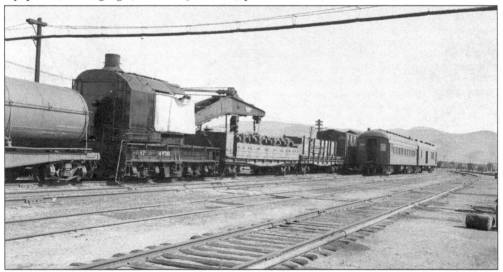

Cranes did the heavy lifting in the rail yard by moving freight from one car to the next or to storage units. They were also used for installing yard equipment and to pick up derailed locomotives or cars. The hook crane shown here could pick up 250 tons. The crane is connected to a tanker car and passenger cars that took workers to derailments. (NDOT.)

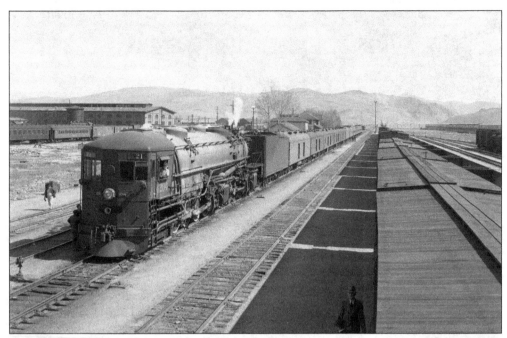

Engine 4204 is shown at the Sparks yards for maintenance in the late 1930s. David F. Myrick describes this photograph in *Railroads of Nevada and Eastern California, Vol. 1*: "Cab-forward No. 4204 was the last of an order for 28 Class AC-8 locomotives of 4-8-8-2 wheel arrangement built by Baldwin in 1939." At this time, Engine 4204 was pulling seven freight cars followed by five passenger cars. (NDOT.)

J.A. McKinnon was the assistant superintendent and J.C. Hanssen was master mechanic in the Sparks yards in 1944. The Sparks and Reno shops, considered some of the busiest during World War II, moved 132,804 freight and passenger cars through their yards in August 1944. Southern Pacific had 973 miles of track in Nevada and about 2,920 Nevada employees, with 1,447 working in Sparks in 1944. (NDOT.)

The Southern Pacific used steam-driven "Leslie type" rotary snow plows with large circular plow blades built by the American Locomotive Company probably in the 1920s and later converted to electric power in the Sparks yards. Snow plows cleared the tracks during heavy snow, but were often left in storage during mild winters. This photograph shows a plow with "wings" on the front that would open to 14 feet. Sacramento and Roseville, California, were known to use these winged plows, but Sparks usually did not. (NHS.)

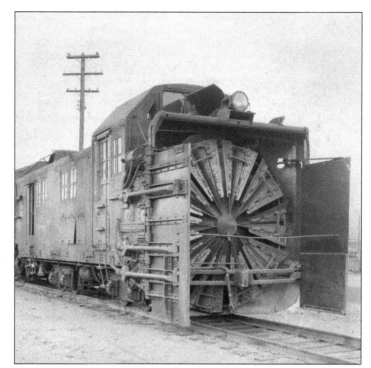

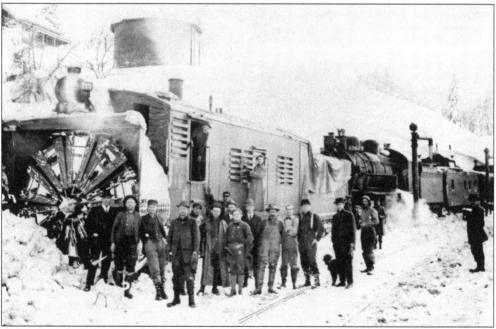

Central Pacific Railroad used a rotary steam snow plow to clear snow off the tracks from Truckee, California, to Reno during a storm in January 1890. Shown is a rotary snow plow that was sent to Blue Canyon in Placer County, California, to remove 59 inches of snow in 1935. In January 1952, the operator of a snow plow was killed when a snow slide buried the plow and pushed it off the tracks; the plow was on its way to rescue 222 people who were stranded for three days in the *City of San Francisco* passenger train. (Sparks Museum.)

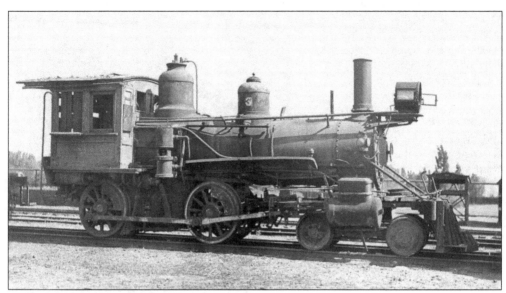

Narrow gauge engines belonging to the Nevada-California-Oregon Railway were often in the Sparks shops for repair. Engine No. 3 (pictured) was salvaged and cut into scrap. Engines Nos. 8, 9, and 18 operated on the Southern Pacific narrow gauge line running from Mina, Nevada, to Keeler, California, on part of the old Carson & Colorado Railroad. (Dick Dreiling.)

This is B Street in the 1920s. Businesses and saloons were restricted to the north side of the Street. Housing for railroad employees was on the south side between Ninth and Fifteenth Streets on the Railroad Reserve. Houses were painted and streets and alleys were graded by the end of 1904. Hotels and general merchandise stores were built. The City of Sparks bragged in 1904 that the city was lit with 1,500 incandescent lights and 15 arc lamps. (Sparks Museum.)

Southern Pacific built a new erecting shop in 1944 to overhaul and repair cab-forward locomotives. This building was steel framed and covered with cement asbestos. It was 250 feet long, 90 feet wide, and 70 feet high and housed 11 repair pits that were each 58 feet long. A 200-ton-capacity traveling crane, the largest in the world, lifted engines and put them into the repair pits. (NSLAR.)

The electric traveling crane is shown lifting AC8 cab-forward Engine 4192. Cab-forward Engine 4260 is off to the side. The wheels and one engine have been removed from Engine 4192. The new erecting shop was servicing the "wartime victory trains" in 1944 but was built to continue servicing engines during peacetime. (NSLAR.)

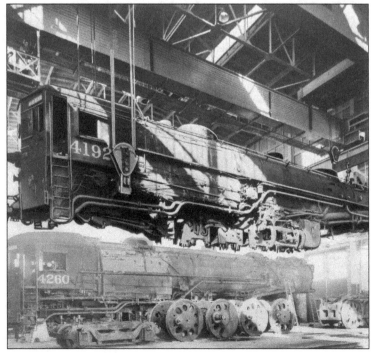

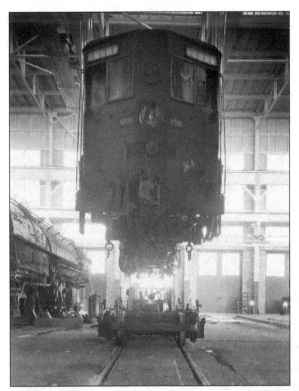

The front end of Engine 4192 is being lifted by the large crane in the erecting shop. A smaller 15-ton Niles crane was used for smaller engines. The Sparks yards had 34 miles of track in the 1940s. Note the notation "Shop" written on the front to tell crews where Engine 4192 needs to go next. (NSLAR.)

Red Cross nurses are shown in front of the railroad hospital located near the depot in 1918. The hospital, built in 1904, was said to be "large enough to accommodate all the sick employees." Dr. J.A. Asher, a surgeon, was put in charge. Workers paid for medical care through a deduction from their paychecks. (Curtis Collection, NHS.)

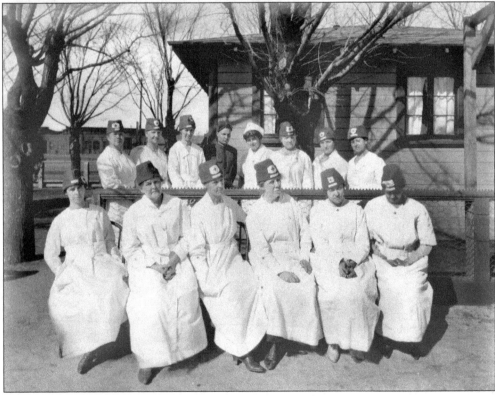

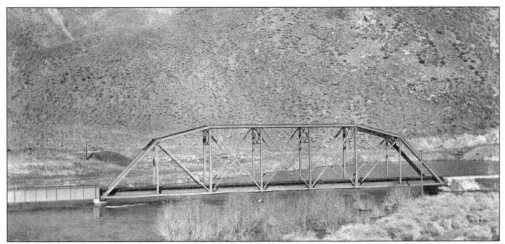

Vista, located four miles east of Sparks at the entrance to the Truckee Canyon, was a flag station for the Central Pacific and Southern Pacific Railroads. The bridge that crosses the Truckee River is shown here in 1912. Daniel W. O'Connor, mayor of Reno in 1905, had a 400-acre ranch near the Vista railroad station in 1864. (NHS.)

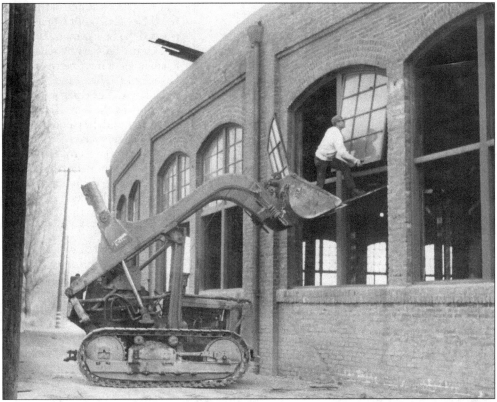

Southern Pacific was changing from steam engines to diesel engines in the late 1940s and early 1950s, leading to the demolition of the historic 54-year-old roundhouse. Crews from Merced, California, began leveling the roundhouse in February 1957 by removing the windows. Heavy equipment then took down the walls. Brick from the building was sold to local used-brick dealers. (Sparks Museum.)

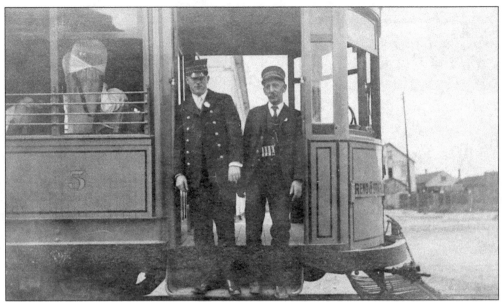

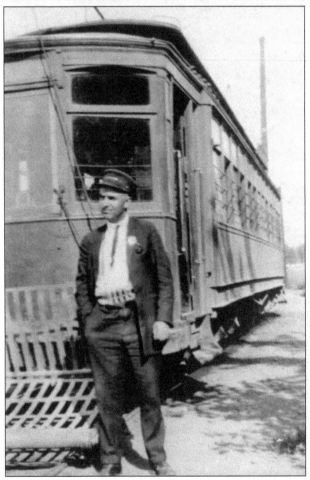

The new streetcar line of the Reno-based Nevada Transit Company reached the Sparks roundhouse in October 1904, with four and a half miles of track between Lake Street in Reno and the roundhouse. The company, which later became the Reno Traction Company, initially painted its five trolley cars yellow. Trolley No. 5 went from Sierra Street to Fourth Street in Reno, then on to B Street and to the roundhouse, where the tracks ended. Note the cradleboard in the window above the "5." (Dick Dreiling.)

H.E. Reid of Gray, Reid, Wright Company; H.J. Darling of Nevada Hardware and Supply Company; and S.H. Wheeler of Wells Estate Company were the principal figures in the Nevada Transit Company. Reno Traction Company asked the state Public Service Commission to allow them to discontinue the streetcars and tear up the tracks in 1927. Shown here is James L. Campbell, who worked as a conductor in 1920. The streetcar went from Reno to Sparks every 30 minutes, with a fare of 10¢ per trip. (Sparks Museum.)

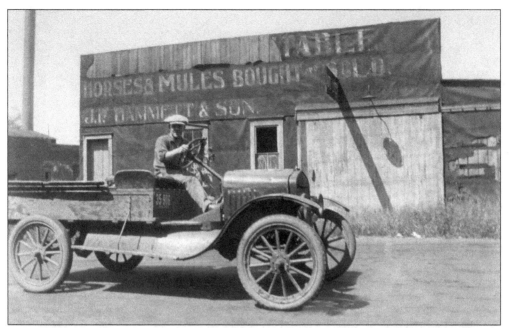

Calavada Auto Company of Reno sold a Ford to a Sparks resident in 1912. L.L. Brown, chief dispatcher for the railroad, and E.W. Jones bought Studebakers in 1914. Automobiles were taking the place of horses, so livery stables were closing. A delivery truck is shown here in front of a closed stable or livery in 1920. The smokestack in the background belongs to the rail yard powerhouse. (NHS.)

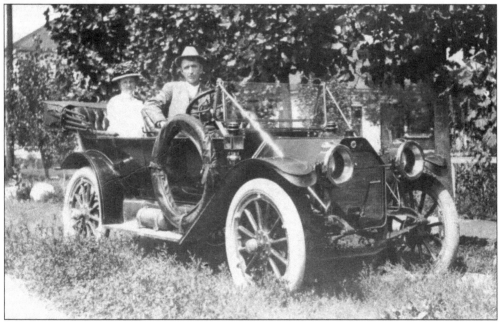

George A. Abbay Jr. and his wife, Eugenia Abbay, are taking a ride in their new Buick near their home in 1918. The Nevada secretary of state issued a license plate to Abbay in 1918. He was a charter member of the Brotherhood of Locomotive Firemen and Enginemen and retired in 1945, then managed the Abbay Hotel on B Street. (Sparks Museum.)

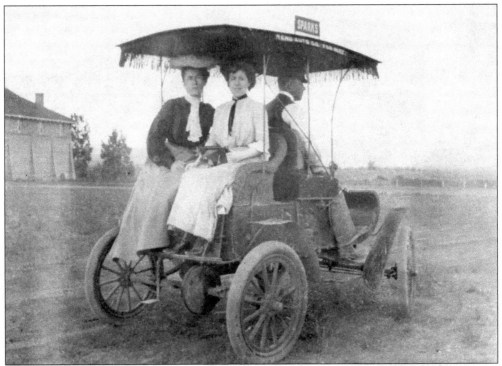

Ethel Nelson Tait (right) may be on her way to Sparks in 1907 in an early taxi or auto-stage. The East Reno auto-stage was operated by "Chauffeur Welshon" in 1904, who ordered an eight-seat Oldsmobile to use for his taxi business. Welshon claimed that he could travel from his office on East 2nd Street in Reno to Sparks in 10 minutes. (NHS.)

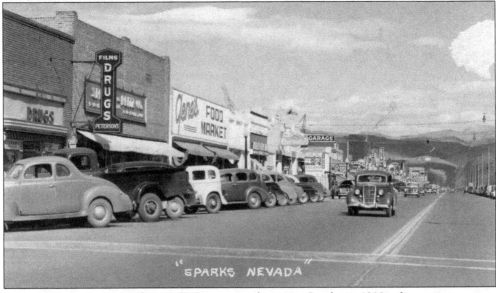

A busy B Street is pictured in 1946. Bus service began in Sparks in 1928, after streetcars were taken out of service. New buses bought in 1939 held 25 passengers on comfortable leather seats. Bus routes were extended in 1944 with stops at the intersections of B Street and Stanford Way and Third, Fifth, and Eighth Streets. (Sparks Museum.)

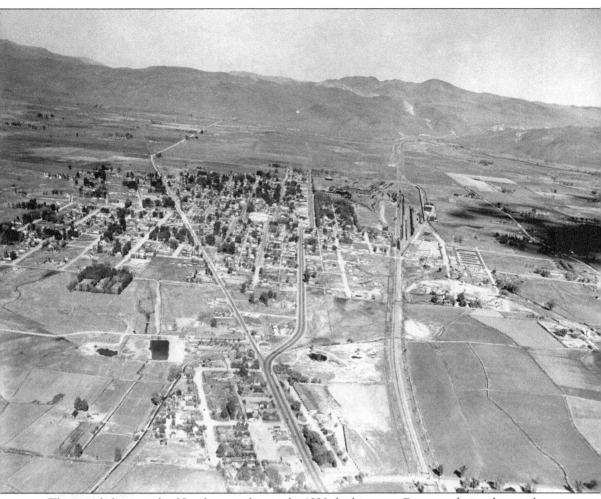

This aerial photograph of Sparks was taken in the 1930s looking east. Farms on the southeast side in the Glendale District belonged to the Mapes, Kleppe, Jones, Raffetto, and Garaventa families. The photograph shows the "Y" between the old County Road (or Prater Way) and B Street (now Victorian Avenue). County Road was the main street leading into Sparks and was the route of the old Central Pacific Railroad track. The Sparks City Council changed the name of County Road to Prater Way in 1939. The Sparks Grammar and High School and the new Robert Mitchell Elementary School were located on County Road. (Jerry Fenwick.)

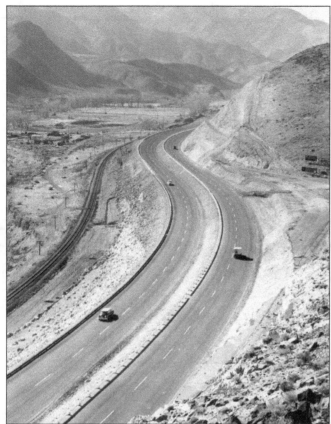

US Highway 40/Victory Highway (now US 80), is shown in Truckee River Canyon east of Sparks in 1954. US 40 originally went through Sparks on the old County Road, but in 1934, it was rerouted on B Street. In 1951, Isabel Construction Company of Reno was awarded the job to build the highway from Sparks to Vista as a four-lane divided highway to be completed by late 1952. Construction continued through 1960, when there were more than 21 miles of four-lane divided highway east of Sparks. (NSLAR.)

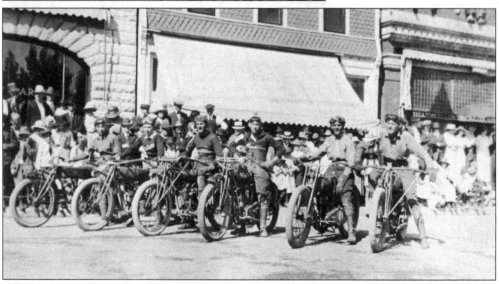

Indian motorcycles are lined up in front of the Bank of Sparks in 1916. Mack Auto Company in Reno was the state distributor of Indian motorcycles in 1914. In 1913, Mack Auto sold a 1912 Indian motorcycle for $175, but also sold used motorcycles for $60. The secretary of state first started registering motorcycles in 1916, when Washoe County had 59 licensed motorcycles. (Jerry Fenwick.)

J.A. Freeman opened Deer Park Service Station and Grocery at 1662 County Road in the early 1920s. Freeman sold the business to Arnaldis C. Willey and W.W. Kullric in 1925. Milan Jeffers was the proprietor in 1933, when a gunman robbed the station of $2 in pennies. (Sparks Museum.)

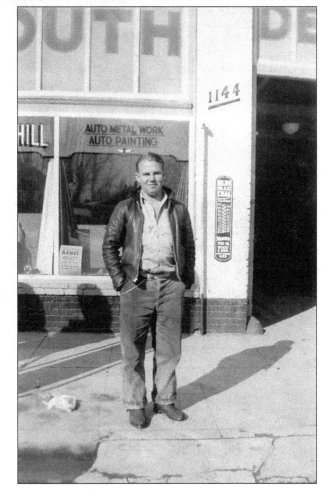

Charles Pettengill is standing in front of the Brown Cahill Garage, an independent gasoline dealer located at 1144 B Street, in 1938. In the May and June 1936 *Nevada State Journal*, the Brown Cahill Garage was listed in an advertisement urging car owners to "Keep Nevada Dollars in Nevada" by buying from local independent gasoline stations. (Sparks Museum.)

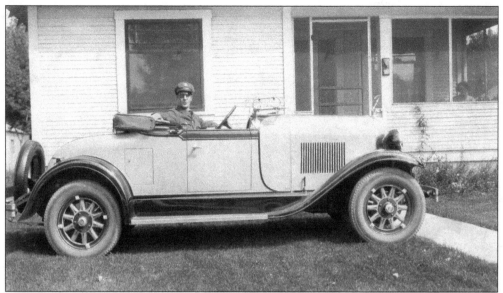

The Sparks Police Department started with one constable in the early 1900s and grew to a force of six well-qualified men by 1941. The Sparks Police Department, headquartered in the new city hall on C Street in 1941, had a modern fingerprinting system and two-way radio communication. An article in the May 23, 1941, *Nevada State Journal* reported that "the city of 5,318 people had the smallest amount of crime per capita of any city in the United States." (Sparks Museum.)

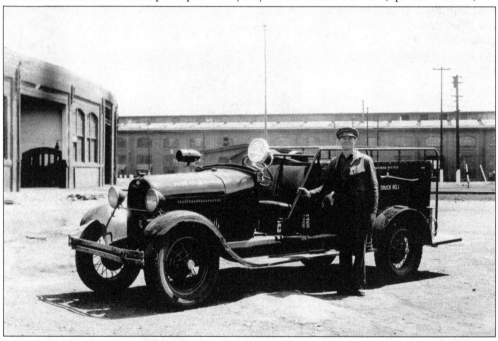

John Casey was a machinist's helper in October 1923. When a fire started near the 55,000-gallon barrel oil tanks, he extinguished the blaze. Casey was named assistant fire chief for the railroad and became fire chief in 1932. He worked for the railroad for 48 years before retiring in 1960. In an interview in the *Reno Gazette Journal* in March 1971, Casey stated, "There were frequent oil fires in the yards—sometimes two or three in one night." (Sparks Museum.)

Members of the Sparks Fire Department are pictured with their truck in the 1940s or 1950s. Sparks had no fire protection in 1904 or 1905. Fred Steiner called a meeting in May 1905 to form a firefighting organization; attending were Fred Steiner, Richard Cook, N. Stewart, James Raines, and Henry Fiege. Frank Malay was named chief of police and fire chief, and Fiege was named assistant fire chief. (Sparks Museum.)

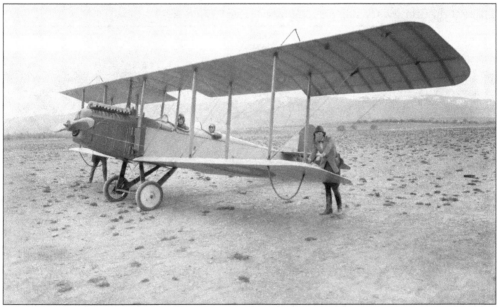

A transcontinental air race in October 1919 featured 47 pilots flying west from Mineola, New York, and 15 flying east from San Francisco. Five pilots landed in or near Reno, with one landing near present-day Vista Boulevard. In the October 18, 1919, *Reno Gazette Journal*, pilots reported that "smoke hung over the city and made it difficult to see." They also commented that "going from Reno to Sacramento was the most beautiful and most dangerous part of the trip." (Roy Curtis Collection, NHS.)

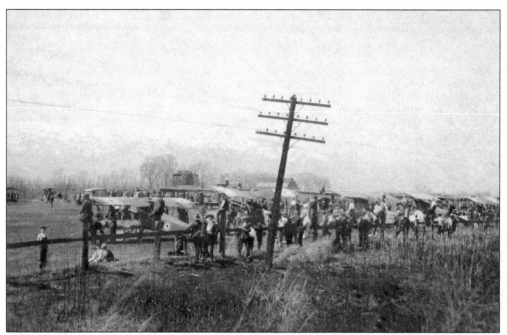

Airplanes taking part in the West Coast Flight of the Victory Loan Flying Circus came to Reno by train on April 15, 1919, to promote the sale of Victory Bonds. The airplanes came to the Sparks rail yards disassembled and packed into end-loading baggage cars, then were assembled on adjoining fields and made ready for the show in Reno. Spectators stand near the fence that separates the field and the railroad right-of-way. (Jerry Fenwick.)

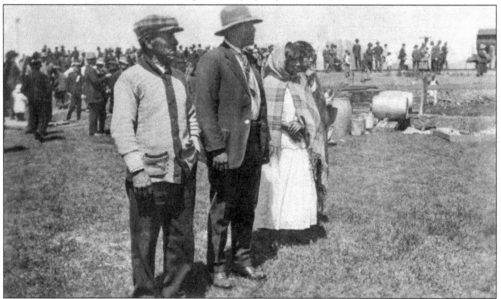

Members of the Paiute tribe are watching the Victory Loan Flying Circus prepare for takeoff for their show in Reno. After the show, the planes returned to the fields by the Sparks rail yards to be disassembled and loaded onto baggage cars to travel to their next show in Salt Lake City. The pilots and crews celebrated at a banquet at the Riverside Hotel and a dance at the Elks Club. (Jerry Fenwick.)

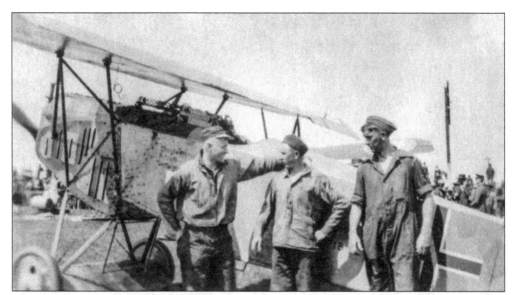

The Victory Loan Flying Circus performed aerobatics and then dropped leaflets containing prizes from local businesses. These prizes included merchandise orders from Sunderlands, Palace Dry Goods, and Gray, Reid, Wright. Palace Bakery contributed a two-pound box of candy and Pacific Coffee Store two pounds of coffee. Shown here are members of the ground crew for one of the German Fokker DV11s used by the circus. (Jerry Fenwick.)

Sparks Airpark opened in 1946 on the Pyramid Highway just outside the Sparks city limits. The facility, owned by Harry "Hank" Schriver, stored small airplanes in "T" hangars similar to private garages. Bob Kronberg, flight instructor, taught students in BT-13s and a Cessna Bobcat. One runway ran along Pyramid Way and another was between Prater Way and O Street near what would become the Greenbrae Terrace Shopping Center in the 1950s. (Sparks Museum.)

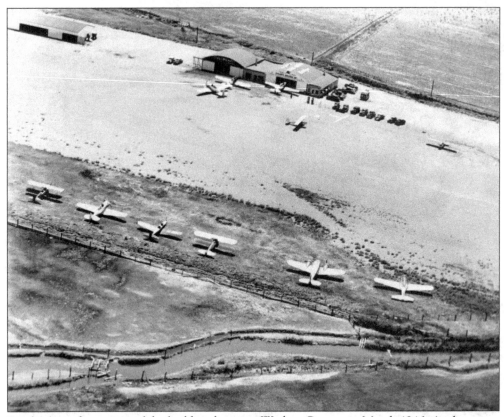

Sparks Airpark was part of the building boom in Washoe County in March 1946. At that time, the Truckee Meadows had three airports: Hubbard Field, Reno's municipal airport; Reno Sky Ranch, located 13 miles from Reno on the Pyramid Highway; and Sparks Airpark, located next to Sparks on Pyramid Highway. Flight instruction and airplane storage were offered at each of the airports. (Sparks Museum.)

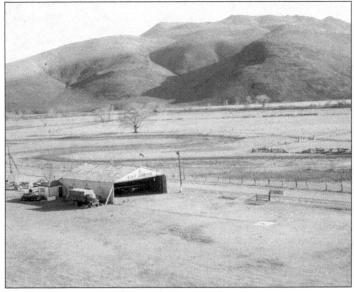

Vista Air Field began operating east of Sparks in 1937 and was used for Civil Air Patrol (CAP) training and search and rescue operations in the 1940s. Alfred Butler leased the field from the CAP in 1955. The field was often flooded by the nearby Truckee River. The Nevada Flyers club used the Vista field from 1940 until it flooded in the late 1940s. (NHS.)

Four

SCHOOLS AND CHURCHES

Schools in the Sparks area were some of the first built in Washoe County. The Stone and Gates' School, later known as the Glendale School, was part of School District No. 6. It was a one-room school completed in April 1864 for students from area ranches and closed in 1958 after 95 years of service. The North Truckee School north of Sparks was built in 1873 and closed in the 1940s, when its students transferred to Sparks schools. Sparks School District No. 29 was organized in March 1904 for students in the new town. The Grammar and High School, completed in 1905, was a two-story brick building on County Road. Mary Lee Nichols School opened in 1917, and a new high school was dedicated the following year. Kate M. Smith School opened in the 1920s. In June 1950, the Sparks School District annexed the North Truckee School, Glendale School, Vista School, and the Spanish Springs School. Sparks schools became part of the Washoe County School District in 1955.

Church services were held in Stone and Gates' Crossing in the early 1860s, with Catholic Mass being held at the Alt farm as early as 1862. Circuit riders traveled through Glendale and the surrounding area from the 1860s through the early 1900s. Rev. E.J. Singer of the Congregational Church held services in a small building on the Ingalls, Hibbard and McPhail tract in February 1904. Charles Stewart was the superintendent of the Sunday school, with Mabel Price as secretary and a Mrs. Staut as treasurer of the Congregational Church. St. Paul's Episcopal Church on Eighth Street is thought to be the first church built in Sparks. Rev. Thomas Bellam moved from Wadsworth to Sparks in 1904 to open it. Emmanuel First Baptist Church was being built in 1904. The Sparks Methodist Church opened in 1905 in the Raines building on B Street. Catholic Mass was also said in the Raines building as early as 1904, with the first Catholic Church built in that year on the corner of Eighth and F Streets. There were five churches in Sparks in 1939, with the *Nevada State Journal* reporting that "these churches have been responsible for creating an environment conducive to right living."

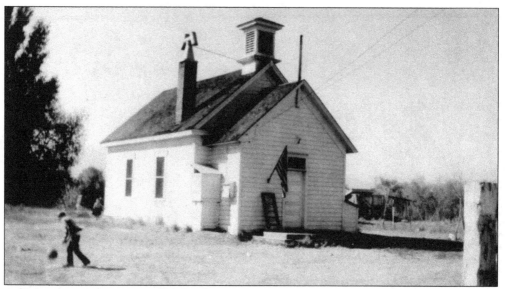

A planning meeting to organize School District No. 6 and build a school for all of Township No. 19 was held at Stone and Gates' Crossing in October 1863. The school, first called the Stone and Gates' School and later the Glendale School, measuring 20 by 30 feet, was built in the spring of 1864 by Archie Bryant. About 30 students attended in 1866. Glendale School closed in 1958. Rev. F.M. Willis, a circuit rider for the Methodist-Episcopal Church, held services in the Glendale School in the 1860s. (Sparks Museum.)

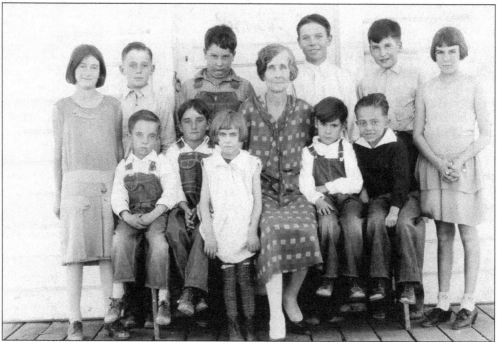

Pictured are elementary students attending the Glendale School in the early 1930s. From left to right are (seated) Darryl Ghiggeri, unidentified, Genevieve Avansino, Gene Oppio, and Freddy Depaoli; (standing) Evelyn Raffetto, Donald Questa, Ernest Caramella, Francis Garavanta, Frank Ferrari, and Gloria Oppio. The teacher may be Mrs. Ross. (Sparks Museum.)

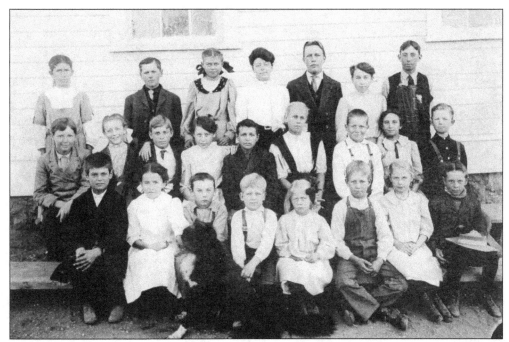

Students at the North Truckee School are shown in 1909. The school, built in 1876, was moved to Wedekind Road (now Queens Way) and North Truckee Lane. The *Reno Evening Gazette* of February 17, 1886, reported that the move "would better accommodate a majority of the scholars of that district." When the North Truckee School was closed and torn down, students were transferred to Sparks schools. (Sparks Museum.)

Sparks School District No. 29 participated in Nevada's Diamond Jubilee in Carson City on October 31, 1939. Teachers in 1904 were Maude Burdette, Goodwin Doten, Ruby North, Lucy Parker, Burtha Twombly, Elizabeth Webster, and Miss Blevin. A senior high school was built in 1917 and opened in 1918. The junior high opened in 1924. By 1920, there were 779 children attending school in the district. (Sparks Museum.)

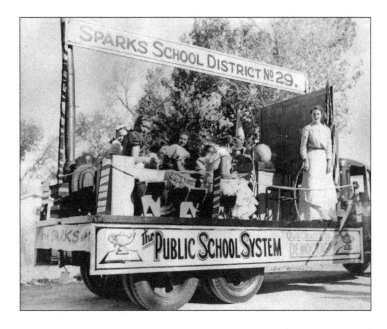

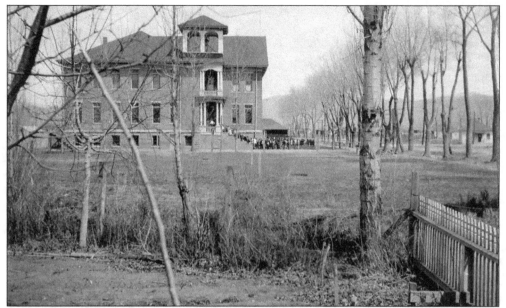

Sparks Grammar and High School, built in 1905, was a two-story brick building with a basement that housed students from kindergarten through high school. The school had special doors installed on the south side classrooms on the first and second floors that opened up to form a large auditorium or closed to make smaller rooms. The building had spacious hallways and stairways. There were approximately 768 students in the Sparks School District in 1926 and about 1,014 in 1940. (Jerry Fenwick.)

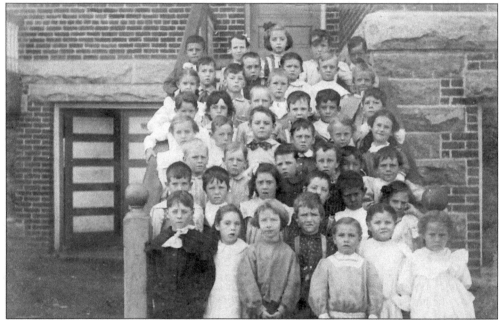

Elementary school students from Sparks Grammar and High School are pictured here in 1907. Frederick DeLongchamps was the architect for the new senior high school as well as the Mary Lee Nichols School and the junior high school built in 1924. The junior high school, a two-story brick building with 11 classrooms, was joined to the high school through a cloister. (Sparks Museum.)

76

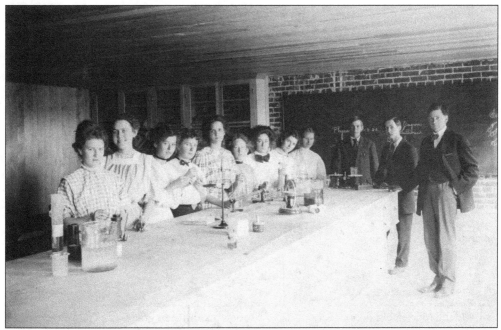

Col. N.C. Prater donated land on the old County Road for the Sparks Grammar and High School. Robert H. Mitchell (on the right) is teaching a chemistry class in the basement laboratory. Mitchell was a science teacher in Carson City, then principal at Sparks Grammar and High School, and eventually, superintendent for the Sparks School District. The grammar school was renamed in 1925 to honor Mitchell. (Sparks Museum.)

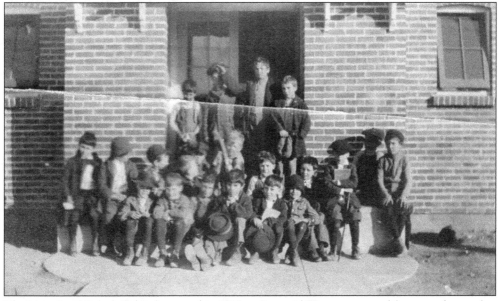

The Mary Lee Nichols School, opened in 1917 on Pyramid Way, was named for a popular teacher at Sparks Grammar and High School. In 1923–1924, Mabel Ingram taught first grade, Agnes Lucy second grade, Lula Hawkins third grade, and Lillian Lewis fourth grade. (Sparks Museum.)

In 1941, the Mary Lee Nichols School had 100 students in three grades. There were only two classrooms in 1917, but the school was expanded in 1920. When the school did not have a playground in the 1950s, D Street was blocked off for recess. The school closed in June 1966. The Washoe Association for Retarded Children (WARC) leased the building for several years for its preschool students and opened a thrift store there in 1971. (Sparks Museum.)

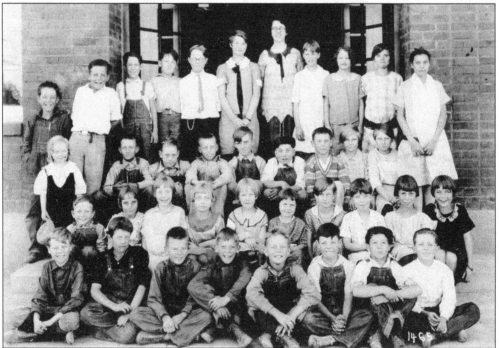

Kate M. Smith Elementary School, named for a longtime Latin, English literature, and history teacher at Sparks Grammar and High School, opened in November 1924 as a four-room school. Mary Lukens was the first principal. There were 130 students in four grades in 1948. (Sparks Museum.)

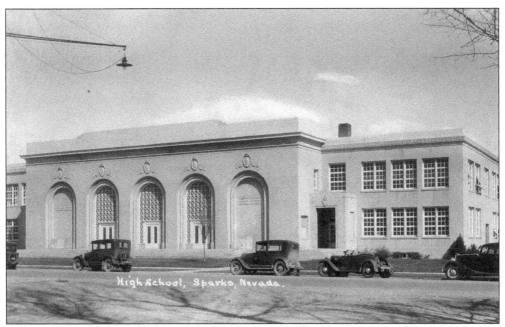

The new Sparks High School was completed at a cost of $70,000 and dedicated on February 15, 1918. Frederick DeLongchamps designed the building with 30 classrooms and a large auditorium and gymnasium with locker rooms and showers. The school also contained chemistry and physics laboratories and home economics classrooms. (Jerry Fenwick.)

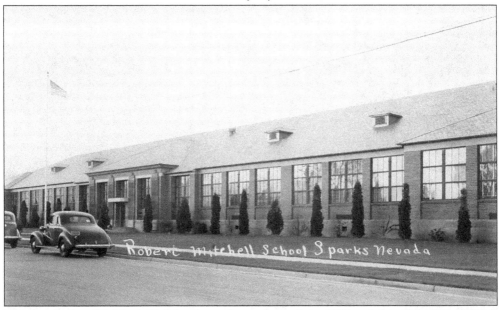

The first Robert H. Mitchell School was deemed unsafe in 1937 and demolished in 1938. A new Robert H. Mitchell Elementary School was built in the same location on Prater Way. Works Progress Administration (WPA) workers and skilled union workers constructed the new building using some material from the old structure. The building is an L-shaped, one-story building with a slate roof. The cost was $214,000, with 45 percent of it paid for by the federal government. (Jerry Fenwick.)

Leota Maestretti, a graduate of the University of Nevada, directed a musical revue at Sparks High School in 1928. The February 28, 1928, *Reno Gazette Journal* reported that "the program will include a chorus, dancing girls, musical selections by the orchestra." Maestretti was the musical director and also taught Latin in 1927 and 1928. (Sparks Museum.)

Tosca Masini, chosen as Miss Nevada in June 1950, was the daughter of Larry and Lucca Masini of Sparks. Larry Masini, a machinist, worked for Southern Pacific for 25 years. Tosca was born in Nevada, graduated from Sparks High School and the University of Nevada, and went on to be a teacher at Sparks Junior High School. She also performed with the Reno Little Theater and Reno Light Opera Guild. (Sparks Museum.)

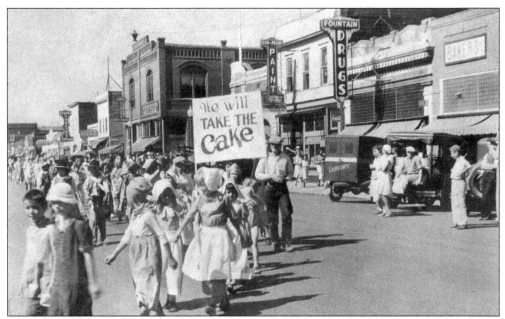

Jack's Carnival started in 1924 when Mary Lukens, Lena Juniper, and Ruby Spoon decided to hold a carnival to help pay for extracurricular programs, hot lunches and milk, clothing, and fuel for needy families and children in Sparks schools. Children dressed in everything "Jacks" as portrayed in Mother Goose nursery rhymes such as Jack and the Beanstalk, Jumping Jacks, Jack-O-Hearts, and Jack-O-Lanterns. (Neal Cobb Collection, NHS.)

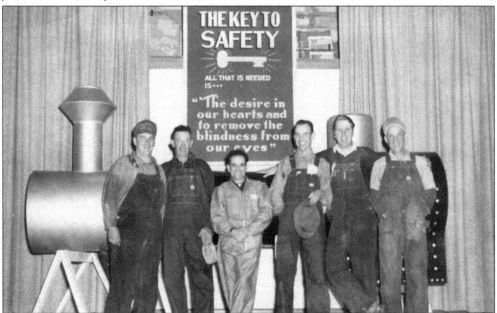

Safety committees were appointed for each railroad division in 1912. Committees made recommendations and set standards to promote safety and prevent accidents. Members of the Sparks Safety Committee in the 1950s included, from left to right, James Ainsworth, Sandro Rossi, "Shorty" Quaresma, Oliver Hansen, Robert "Jitterbug" Kolurch, and unidentified. The men are explaining the importance of safety to students at Robert H. Mitchell Elementary School. (Sparks Museum.)

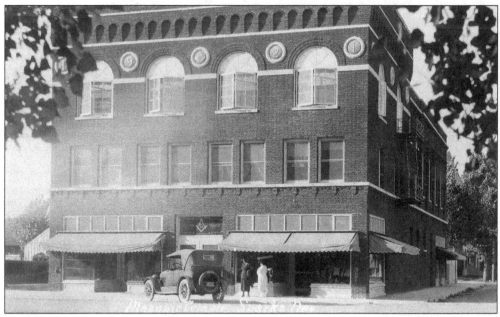

The Wadsworth Masons moved to Sparks in 1905 and held meetings in a building at Fourth and D Streets and later in the Robison building. The new Masonic Temple shown here was built on the corner of Twelfth and B Streets and dedicated on December 21, 1921. The lodge room was on the second floor and a dining room was on the third floor. The Brotherhood of Railway Trainmen, the Christian Science Society, Dr. Henry L. Dalby, and the post office were on the main floor. (Jerry Fenwick.)

Fr. Thomas Horgan, the first priest assigned to Sparks, was appointed in 1904 to establish the first Catholic church and rectory in the O'Sullivan Tract at F and Eighth Streets. The Immaculate Conception Church, made of wood, cost $5,000 to build and had a parochial residence next door. Candles left burning on the altar completely destroyed the church on Easter Sunday in 1930. The rectory was partially burned. Father Horgan died in California in January 1931. (Dick Dreiling.)

Fr. Patrick O'Conner came to Sparks in 1931 to rebuild the Catholic church at 590 Pyramid Way. The Immaculate Conception Church, shown here, designed by Frederick DeLongchamps, was listed in the National Register of Historic Places in 1992. The church bell, thought to be cast in the early 1800s, was purchased from the Virginia City firehouse in 1941. (Dick Dreiling.)

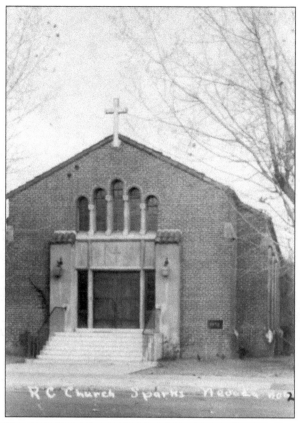

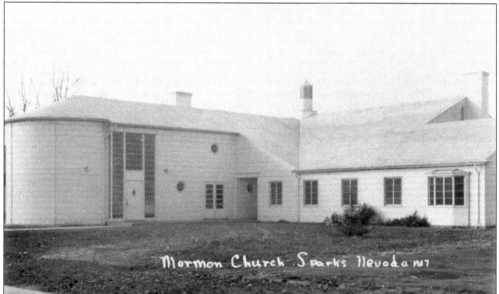

The first Mormon church in Sparks was built in 1909 at 1021 C Street. The second Church of Jesus Christ of Latter Day Saints (shown here) was built in the 1940s at 1114 Prater Way for the first, second, and fourth wards. The Sparks church became part of the Reno Stake in 1940. (Dick Dreiling.)

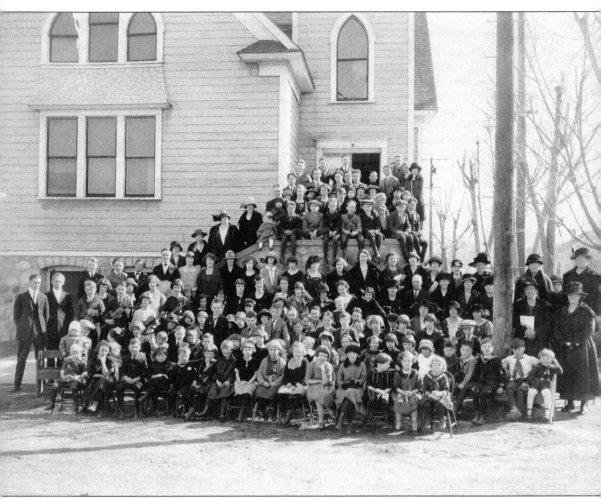

Members of the First Baptist Church of Wadsworth voted to move their church to the new city of Sparks in 1904. A temporary church, renamed Emmanuel First Baptist Church, was built on a lot on Twelfth and C Streets. Later, in 1904, the church purchased a lot one block north at the corner of Monroe and Hood Streets (now Twelfth and D Streets). Lumber from the Wadsworth church was used to build the new church. Gov. John Sparks donated the stained-glass windows. (Sparks Museum.)

Five

WORKING AND PLAYING

Businesses in Wadsworth followed their customers to the new town of Sparks as the Southern Pacific relocated its operations and employees to the area. Sparks had a mercantile store in 1904, a bank by 1905, and realty companies, restaurants, saloons, and hotels. The November 14, 1939, *Nevada State Journal* reported that Sparks was "one of the state's leading industrial cities." When the railroad closed its roundhouse and shops, rail workers stayed in Sparks to open their own businesses or to work in the growing Nevada hospitality or warehousing industries.

Sparks became a strong union town. Union members marched and had floats in every Labor Day and Armistice Day or Veterans' Day parade. In 1924, Sparks started Jack's Carnival to raise money for the schools. Many Sparks residents and railroad workers enlisted in World War I and World War II; those who stayed home in World War II participated enthusiastically in bond sales and salvage drives. The railroad took deductions from paychecks to support both wars. Today, Sparks celebrates the Best in the West Rib Cook Off, observes Christmas with a parade and a Santa's village, and has a large farmers' market with the 39 North Marketplace. Sparks has 50 city parks and a large marina on an 80-acre lake. Once known as the Rail City, Sparks now uses the slogan "It's Happening Here" to celebrate the city's many activities.

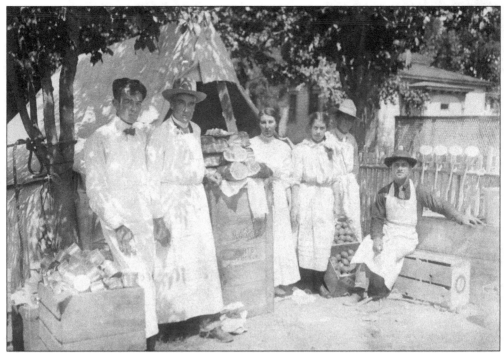

James Hawkins, a butcher, is standing at his sales booth with his family in a Labor Day celebration. Labor Day celebrations took place in Reno in 1906, in Carson City in 1907, and in Virginia City in 1908, since Washoe, Storey, and Ormsby County officials agreed to hold parades in their respective counties in alternate years. A banquet for all union men and their families was held at the Nevada Hotel grounds at the corner of Fourth and Lake Streets in Reno in 1906. (NHS.)

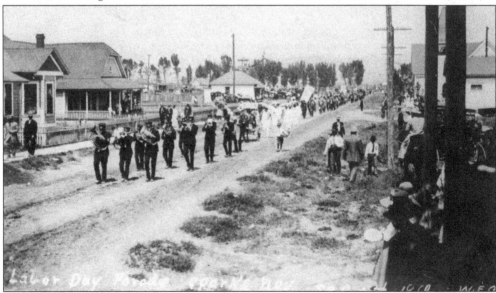

Labor Day celebrations in Sparks on September 5, 1910, were dubbed "the greatest celebration in the history of the city" by the *Nevada State Journal*. The parade was in the morning, followed by a barbecue and sporting events in the afternoon and a grand ball in the evening. Sheet metal workers took first prize, and the blacksmith's anvil float won best float. (Dick Dreiling.)

Youngs' Hotel offered games of chance when gambling was legalized in 1909. Frank and George Young were arrested in August 1909 for using loaded dice in a craps game, but the case was dismissed in October. Fred Lipman was the cashier in October 1909. In 1914, the Young brothers tried to sell their hotel with advertisements in local papers reading "Youngs' Hotel in Sparks. This has been one of the best paying businesses in the state and the opportunity is still there." Interested parties were told to inquire at Austin & MacPhersons. (Jerry Fenwick.)

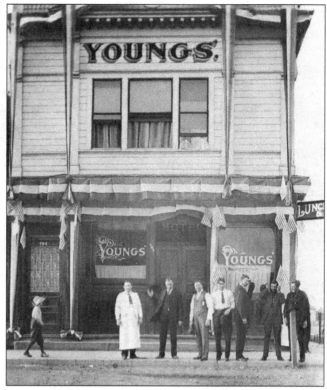

Coney Island was a family amusement park opened on June 20, 1909, by Otto G. Benschuetz. Dances were held in the open-air pavilion, and the park also featured an ice-cream pavilion and a bicycle merry-go-round for children. Coney Island was open daily from 9:00 a.m. to 10:00 p.m. Advertisements stressed that "Liquor will not be served in the pavilion or picnic grounds," only at the Park Bar. (Sparks Museum.)

Coney Island, on the border between Reno and Sparks, had a man-made lake where guests could rent gas-powered boats and paddleboats. When owner Otto G. Benschuetz died in 1912, the park was in debt, so his son Max turned the open-air pavilion into a dance hall and drinking establishment. Coney Island closed in 1918 when Prohibition outlawed the sale of alcohol. An aircraft assembly plant was located on this site in 1920. (Sparks Museum.)

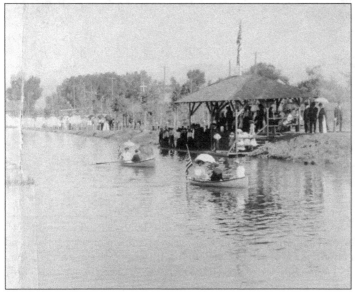

At Coney Island, there was a wire fence around the lake, and the sides of the lake were terraced. Visitors could rent rowboats for a nominal fee. The June 26, 1909, *Reno Gazette Journal* reported that "nothing has been overlooked that will add to the pleasure of those who go out for a good time." (NHS.)

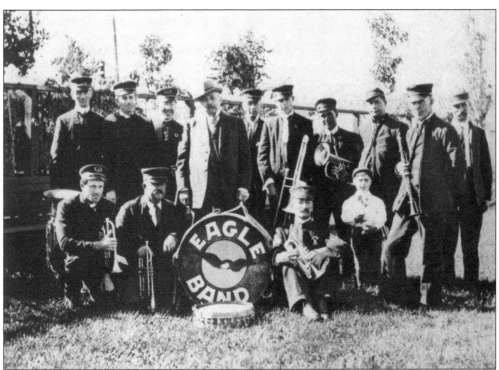

Musical and "high-class" vaudeville programs were planned for Coney Island. The Eagle Band played every Sunday in September and October 1909 for dancing in the open-air pavilion from 3:00 p.m. to 7:30 p.m. Otto Benschuetz, the park's proprietor, is standing behind the drum. The Eagle Band performed at concerts and dance socials in the Reno/Sparks area for several years. (NHS.)

Gladys Huyck (left) and Mrs. Gallagher are dressed up as a hunter and a fisherman for fun. Huyck and her husband, Curran, a brakeman and later conductor, moved to Sparks in 1910. Curran died in a railroad accident in 1937. Gladys Hyuck ran for mayor of Sparks in the 1920s on a platform promoting curbs, gutters, and street-paving. She served as the postmaster in Sparks from 1940 to 1961. (Jerry Fenwick.)

An unidentified woman is shown standing in front of a water supply map of Reno and Sparks, possibly in the Sparks city offices in 1914. The map shows the North Truckee Ditch in the Prater Addition; the Stephens-Frick Ditch at the east end of the rail yards; the Pioneer Ditch near Glendale; and the Glendale, Sullivan, Kelley and Orr Ditches near the west end of Sparks. The Stephens-Frick Drain Ditch was considered the "natural outlet for drainage for the entire district of Sparks" by Sparks city attorney G. Fletcher. (NHS.)

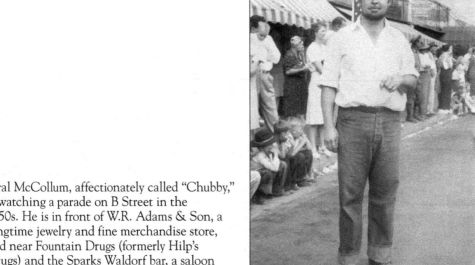

Oral McCollum, affectionately called "Chubby," is watching a parade on B Street in the 1950s. He is in front of W.R. Adams & Son, a longtime jewelry and fine merchandise store, and near Fountain Drugs (formerly Hilp's Drugs) and the Sparks Waldorf bar, a saloon that served Sierra Bock beer on tap. (NHS.)

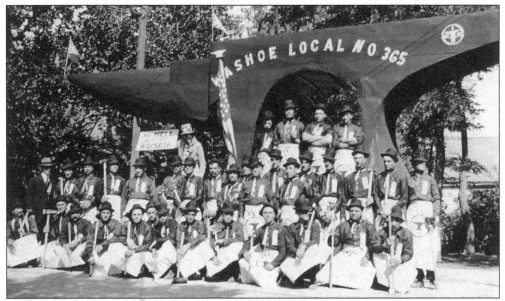

Members of the blacksmiths' union participated in the 1910 and 1918 Labor Day parades with their large anvil float. When the armistice ending World War I was signed on November 11, 1918, Reno and Sparks residents celebrated along Virginia Street in Reno. Sparks railway workers declared it a holiday and joined the parade. The blacksmiths' union may have marched with their anvil float and a "To HELL with the KAISER" sign at that time. (Jerry Fenwick.)

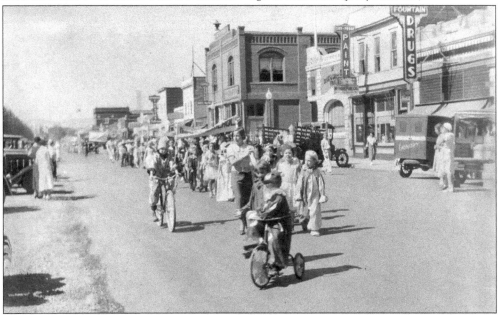

Robert H. Mitchell, Mary Lee Nichols, and Kate M. Smith Elementary Schools, along with the junior high and high school, participated in the annual Jack's Carnival parade along B Street in the 1930s. The theme in October 1932 was "Jack of Hearts," with Jack Frost ice cream, Jack Sprat sandwiches, and Jack of All Trades salad. Photographs were taken in the Jack Horner photograph booth, and the flower booth was Jack-in-the-Pulpit. Entertainment was by Jack Black Music. (Neal Cobb Collection, NHS.)

Women sell war bonds to Sparks railroad workers on December 23, 1944. The *Nevada State Journal* reported that $15,275.25 worth of E-bonds had been sold to railroad laborers, track workers, yardmasters, and engineers. From left to right are Louis Allard, Barbara Shelly, Jack Clark, Gladys Huyck, and Evelyn Todd. Washoe County exceeded its quota of $450,000, selling $453,753 worth of bonds. (Sparks Museum.)

B Street Park, a small tree-lined park stretching five blocks from Ninth Street to Fifteenth Street on the south side of B Street, may have been built between 1905 and 1910. The emergency hospital and railroad library were at the western end of the park. Trees were decorated at Christmas, when Santa sat near the park's bandstand. Pres. Harry S. Truman made a campaign stop at the bandstand on September 18, 1948. (Sparks Museum.)

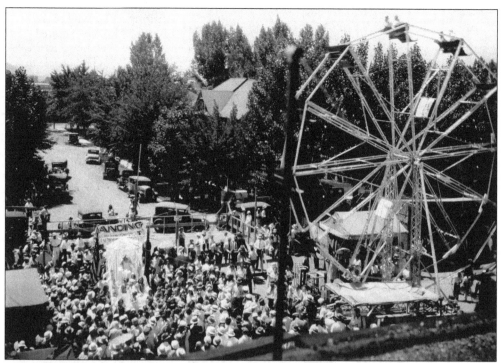

This photograph was taken from south of B Street (possibly between B and A Streets) and shows the carnival and street dance held for the 40th anniversary of Sparks in 1944. Because of a manpower shortage during the war, Southern Pacific hired 32 men from Mexico to work in the car shops; they joined the festivities with an international village featuring dancers, singers, and contests. (Sparks Museum.)

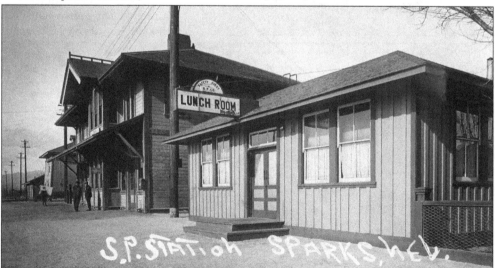

M.S. Marshall was appointed ticket clerk at the Sparks passenger station in 1907. The passenger station was open only part time in 1932, when passenger trains were not going through Sparks. Southern Pacific announced the end of all passenger service in Sparks in June 1946. After the announcement, Sparks mayor Dan Fodrin stated, "The Southern Pacific has chosen to leave a city of 7,000 persons virtually without passenger service." (Jerry Fenwick.)

Christopher C. Walker and his wife, Ann, are pictured in front of their home in the 1940s or 1950s. An article in the *Sparks Tribune* on June 30, 1976, reported that the Walker home at 401 Sixth Street was built by Christopher's father, Jonathan Walker, in the early 1900s. Christopher bought the house, listed as a "15 room furnished house," in 1917. Railroad workers often stayed in the second-floor rooms after traveling to Sparks from Imlay, Carlin, or Elko. (Pat Ferraro Klos.)

Contractors Rousch and Belz began work on the new Sparks branch of the Washoe County Library in June 1931. The library was located on B Street opposite the Southern Pacific gates. The building, designed by Frederick DeLongchamps, opened in January 1932 with the Justice Court on the first floor and the library on the second. The Sparks Museum and Cultural Center now occupies this building. (Sparks Museum.)

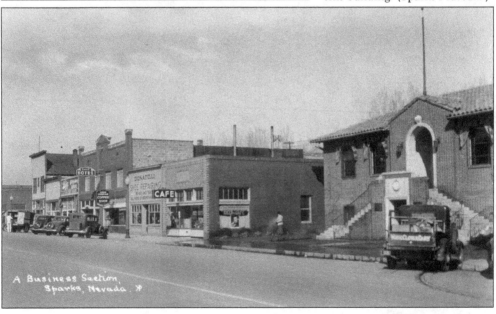

A Business Section, Sparks, Nevada.

The Sparks City Hall and Fire Department was designed by Reno architect Russell Mills and built in 1940–1941 for $38,000. The dedication ceremony was held on Saturday, June 21, 1941. The *Reno Evening Gazette* reported on June 21 that "the new Sparks city hall is another tangible evidence of Sparks' progressive spirit." (NSLAR.)

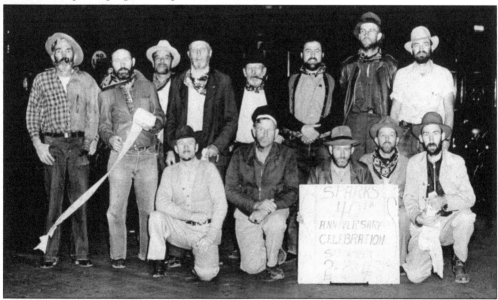

The Whiskerino Beard Growing Contest, a part of the Sparks 40th anniversary celebration, was held on Labor Day, September 4, 1944. Men started growing beards at least a month before the contest in an attempt to win prizes such as $5 in war stamps (for the youngest contestant) and a $25 war bond (for "the fullest and longest" beard). Bill Foote, Bob Baker, Fred Steiner Sr., and Jim Guidi were among the participants. (Sparks Museum.)

In 1912, The first slogan for the railroad safety committee was "Safety First." In 1931, engineers G.W. Culver, B.E. Eager, and E.J. Rowse, along with firemen R.C. Haden and G.A. Raney, won gold buttons for efficiency in railroad safety work. The group in this 1950s photograph is promoting the slogan, "You have a heart put it in safety." (NHS.)

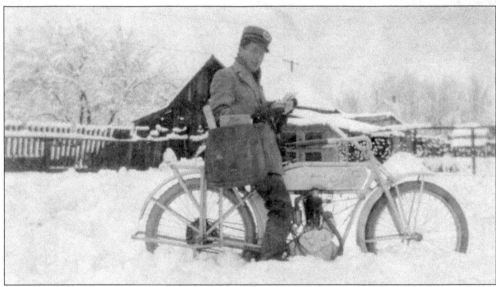

Mail was delivered by motorcycle to Rural Route 2 Glendale residents during one winter in the 1910s. The first post office in the area was the Glendale post office, which opened in 1864. Harriman's first post office was in the Sol Summerfield building just outside the Railroad Reserve in 1903; the post office was later moved to the Courtland Hotel (or Steiner Building) on B Street, then to the Masonic Building in 1925. (Sparks Museum.)

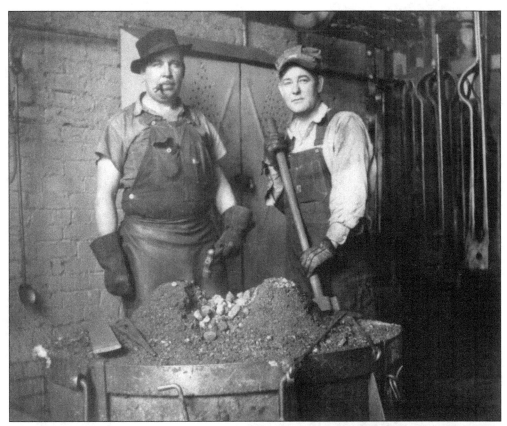

Oral D. McCollum (left) is shown working in the railroad blacksmith shop in the early 1930s. McCollum worked for the railroad for about 12 years before opening his own business, Sparks Blacksmith & Welding, in a Quonset hut on east Prater Way near North Truckee Lane in the late 1940s. McCollum's shop did ornamental iron work, general blacksmithing, tool sharpening, trailer hitches, and fender and bumper repair. (Sparks Museum.)

Railroad firemen, like the one pictured here, had one of the highest paying jobs on the railroad, for they were responsible for keeping the engines running. The Brotherhood of Locomotive Firemen and Engineers, Lodge 19, represented firemen and engineers in Wadsworth and then in Sparks. Meetings were held every Tuesday at the Engineers Hall. E.D. Ford was president in 1932, with E.M. Ranson serving as vice president and John Cottrell as financial secretary. (Sparks Museum.)

W.C. "Furgie" Furguson, a railroad engineer, is greasing Engine 18 somewhere away from the Sparks yards. Engineers often started working part time, putting their names on the "Extra Board" and waiting for the crew dispatcher to call, or some started as firemen before being promoted to engineer. (Sparks Museum.)

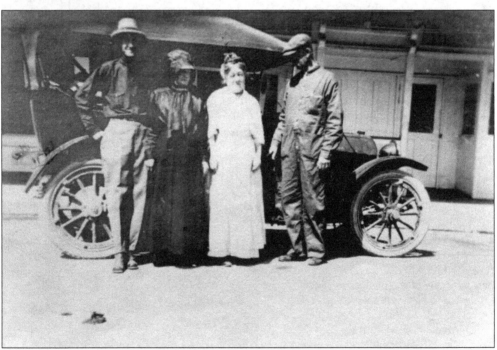

From left to right, Henry "Chick" Gazin; his mother, Mary; his father, William; and an unidentified friend are standing in front of the movie theater on the northeast corner of Ninth and B Streets in 1916. Gazin opened Gazin's, a men's clothing store, in 1928. A women's department was added two doors down from the original store in 1942, and renovation connected the two stores in 1956. A second story was added in 1970. Glen and Miriam Judd, who had worked with Gazin for several years, bought the store in 1993 when Chick retired. (Sparks Museum.)

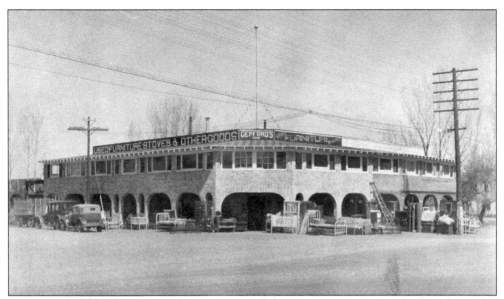

Harry L. Gepford opened Gepford's Cash Store, a used furniture store, in 1930. There were two-room apartments for rent on the second floor. Gepford's was buying and selling new and used furniture in 1938. The store, at 1446 Prater Way, was still in business at the time of Gepford's death in 1963. D&L Country Store with Ann's Turquoise was at this location in 1972. (Neal Cobb Collection, NHS.)

Sparks Lumber and Coal Company, purchased by Ray Peterson and Roy J. McCaslin in 1938, was the go-to source in Sparks for construction and finish lumber, plumbing and electrical supplies, window glass, and Glidden paints. An article in the June 8, 1949, *Nevada State Journal* reported that the company sold a complete line of building material and fuel. The store was located at Fifteenth and B Streets. (Sparks Museum.)

A yard worker is shown standing in the rail yards in the 1940s or 1950s. The yardmaster, switchman, manifest clerk, call girls or call boys, caboose supply man, coach cleaner, car inspector, and yard checker worked in the yards. The yard checker verified all of the freight cars as they came in. Call girls or call boys notified railroad workers at home when they were needed. (NHS.)

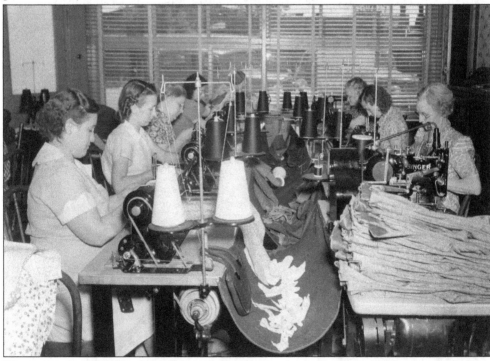

The women employed in this WPA sewing project made clothes for needy families throughout Nevada beginning in 1940. The Sparks project was described in the August 26, 1940, *Nevada State Journal* as a "completely electrically controlled unit in Sparks, equipped to operate on an industrial basis." Electric sewing machines and new treadle machines were used to make sheets and pillowcases, children's school clothes, mufflers, and woolen shirts. (NHS.)

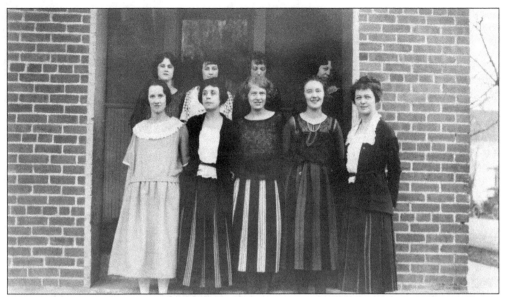

A new dial telephone system began operating in Reno and Sparks at 1:00 a.m. on June 2, 1929. Residents were told that they would no longer hear "Number, please," but could instead dial numbers directly. They were to use the new "Blue Book" to locate telephone numbers. This group of unidentified operators is standing in the doorway of the new telephone building at 1124 C Street. (NHS.)

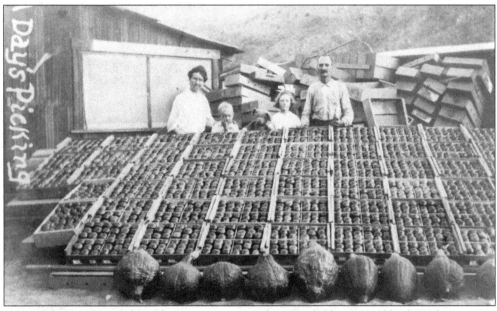

C.J. and Corinne Fairchild sold tomatoes, tomato plants, and other vegetables from their tomato farm near Vista (four miles east of Sparks) in the 1920s and 1930s. An advertisement in the September 11, 1925, *Nevada State Journal* proclaimed that tomatoes were ready for canning. C.J. and Corinne are pictured along with their children Elaine and Romeyn after a day's picking of squash and tomatoes. C.J. worked as a car builder for the railroad before opening the tomato farm. (Sparks Museum.)

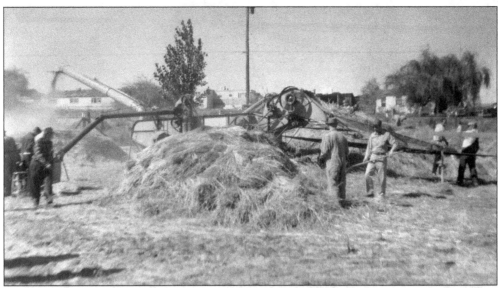

Calvin Tinkham, along with members of the Nevada Heritage Association, held an old-fashioned threshing bee at the Washoe County Industrial and Agricultural Fair on north Wells Avenue in Reno in September 1960. Tinkham operated a 1928 McCormick-Deering tractor pulling a 1926 John Deere binder. A 1914 steam tractor and a 1920 internal combustion cross-engine tractor were on display at the fair. (NHS.)

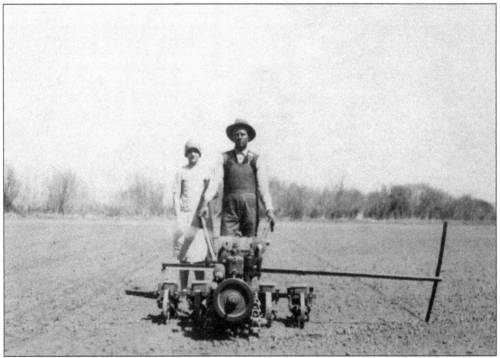

John and Pearl Kleppe, shown here in the 1920s, sold two train car loads of onions to Wood, Curtis and Company of Sacramento in 1897. John Kleppe was the secretary for the Washoe County Water Conservation District in the 1930s when the district signed an agreement to construct a reservoir with a capacity of 40,900 cubic feet on the Little Truckee River at Boca. (NHS.)

B.M. Shelly and A.J. Krehmke opened Modern Home Mart, a hardware store, in 1921 at 1130 B Street. Carl Shelly and Mike Shelly joined the store in 1930 and 1934. The Shellys bought Krehmke's interest in 1939. Carl Shelly was a Sparks city councilman, served in the Nevada Assembly from 1934 to 1940, was a Washoe County commissioner, and became publisher of the *Sparks Tribune* in 1950. (Sparks Museum.)

Sparks had two hardware stores in the 1930s, including this one owned by Harry Gray on Ninth and B Streets. Gray was a Washoe County assemblyman from 1935 to 1937 and was a real estate salesman in the 1940s. Robert Baker bought the hardware store in 1943 and renamed it Baker's Furniture and Hardware. Baker moved the hardware portion of his business to a new location at 922 B Street in June 1966. (Sparks Museum.)

Two unidentified railroad workers are resting and eating lunch near the lockers in 1944. In their hands are bond certificates purchased for the Sparks "Buy a Bomber" campaign that started in 1944. The campaign earned $600,000, which was enough to buy a Boeing B-25J bomber named *Spirit of Sparks*. (Sparks Museum.)

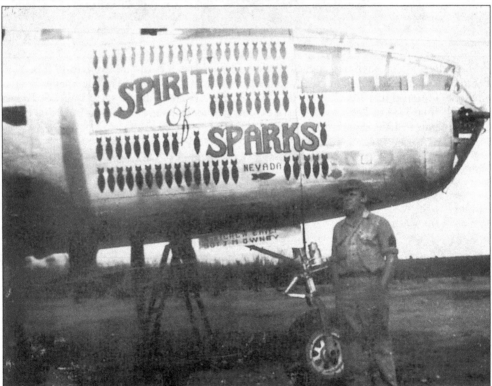

The fifth war bond drive, to raise money to buy a bomber, started in Sparks in June 1944. A wooden replica of the bomber was erected at B Street Park to record bonds purchased. The *Spirit of Sparks* served in the European Theater as part of the 428th Bomber Squadron, 310th Bomber Group, 12th Air Force. (Dick Dreiling.)

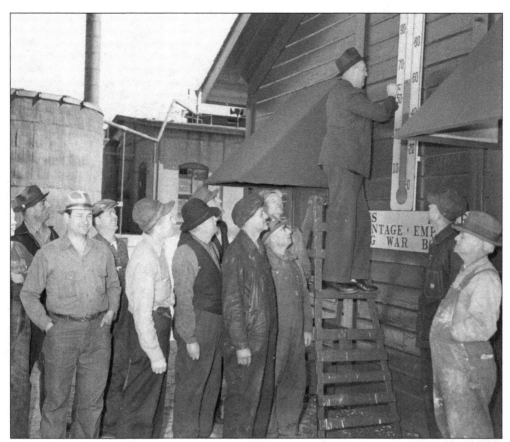

The rally for the third war bond drive was held in the Sparks yards in September 1943. Waldo Hastings, a vocational shop instructor at Sparks High School, created this thermometer to tally sales. Another thermometer was located at the B Street Park. Hastings was a draftsman and apprentice instructor for the railroad in 1920, then taught vocational shop at Sparks High School beginning in 1925. The drive had reached the halfway mark by September 17, with a grand total of $121,628. At the end of the drive, Sparks had sold $276,523 worth of bonds. (NSLAR.)

Many Sparks residents came out to support the troops and help in the war effort. The Sparks rail yards had an air raid siren installed and operational by the end of December 1941. Girl Scouts collected hot water bottles, thermometers, and bandages. The Sparks Red Cross set up sewing rooms to make hospital gowns and bath robes. Residents were asked to donate old pots and pans for an aluminum drive. (NSLAR.)

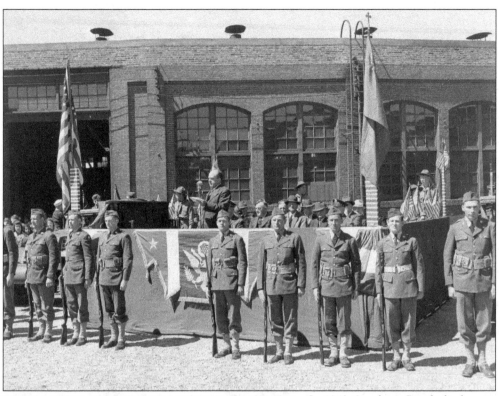

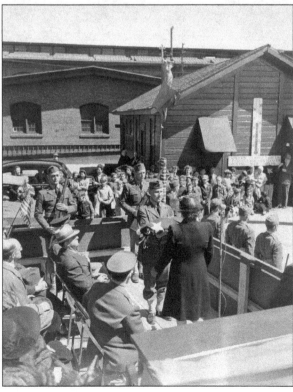

In 1943, Southern Pacific had 12,000 workers in the armed forces. The Reno Army Air Base participated in a war rally to honor those employees in 1943. Lt. Col. Adrian P. Cote of the Reno Army Air Base stated: "I am proud to state that purchases of war bonds by both the civilian employees and military personnel at the Reno Army Air Base are such to have received commendation from higher commands." (NSLAR.)

Carl Shelly, Edwin Mulcahy, Robert Adams, Joseph Sbragia, Kate Reiley, and Gladys Huyck took part in a planning meeting for the third war bond drive. The quota for bond sales was $250,000. Young men from Sparks began enlisting in the fall of 1939, and 631 had joined by the first draft, which was held on October 16, 1940. The rally was held in the rail yard between the roundhouse and the machine shop. (NSLAR.)

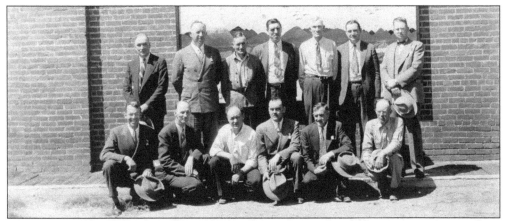

The Sparks War Service Day Committee members pictured here are, from left to right, (first row) Oliver Hansen, W.W. Schipper, Mel Poole, H.L. Covington, P.M. Smith, and J.F. Henley; (second row) J.G. Lusich, J.C. Hanssen, A.W. Rock Sr., Louis Zunino, Tim Brough, Nelo Giannotti, and G.H. Wilson. The Sparks War Service Day was held on June 15, 1943, to honor all railroad employees in the armed forces. J.C. Hanssen opened the rally, with music provided by the military band from Reno Army Air Base. (Sparks Museum.)

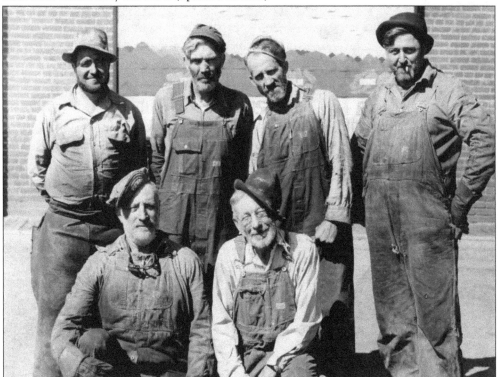

Yard workers took part in the War Service Day activities and posed before the maintenance building in 1944. Lieut. Col. Adrian P. Cote of the Reno Army Air Base and Nevada attorney general Alan Bible told a group of about 1,000 people about the railroad's role in the San Francisco earthquake in 1906 and said, "The company is playing a part equally as important today in transporting vital war materials to points of embarkation." The program ended with Chet Christensen, accompanied by Verda Whitehead, singing "On the Road to Mandalay." (Sparks Museum)

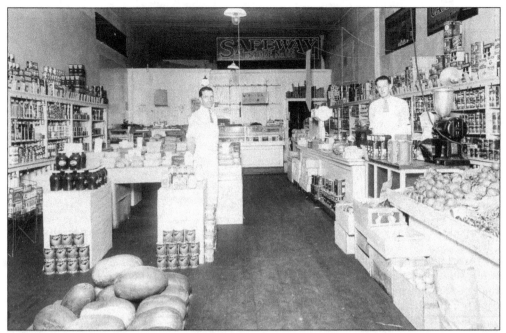

The Piggly Wiggly grocery store was located at 1246 B Street in 1930. On Wednesdays, shoppers could buy sirloin steak for 35¢ per pound. Sewell's took over all of the Piggly Wiggly stores in Reno and Sparks in January 1936, promising larger and better arranged stores. James Armstrong is shown behind the counter in the 1930s. (Sparks Museum.)

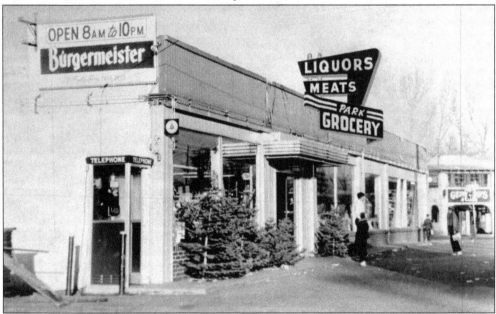

In 1950, Ronald "Clete" Rinehart bought the Park Motel at the corner of Fifteenth Street and Prater Way from Magdalena Kendall and remodeled it as Park Grocery. The store had a full-service butcher shop and a wall of slot machines. In 1959, Park Grocery became the first grocery in Washoe County that remained open 24 hours a day, seven days a week. Park Grocery closed in 1988. (Sparks Museum.)

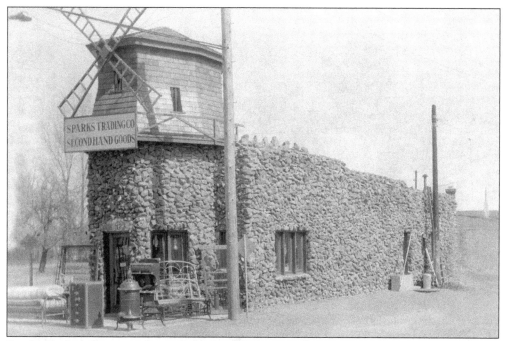

Sparks Trading Company, located at Fifteenth Street and County Road (now Prater Way) sold used furniture in the early 1930s. Its stock of used furniture and tools was sold at cost in 1933. Albert R. Cave operated a grocery store known as Cave Grocery (or Rock Cave Grocery) here from 1939 to 1944. Wanda's Grocery, at the same location, was owned by Wanda Hammersmith from 1946 to 1953. (NHS.)

Sparks celebrated the opening of the new pool at Deer Park on May 30, 1942. Awards were given in contests for pie-eating, the homeliest man, the handsomest man, the person with the most freckles, and the woman with the most children. There was even a bathing beauty contest; Doris Korb (on the far right) was one contestant. (Sparks Museum.)

Pictured are the contestants in the pie-eating contest held at the opening of the Deer Park pool. The celebration began at 1:00 p.m., with swimming events starting at 2:00 p.m. Motion pictures were shown at 9:00 p.m., with Technicolor film of scenes of Sparks shown alongside patriotic and educational films; a dance followed. (Sparks Museum.)

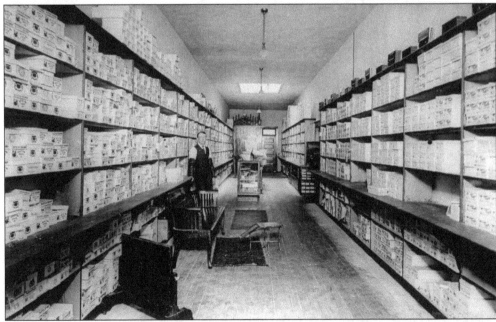

In 1909, Al Blundell, Sue Peterson, and Pete Peterson opened The Toggery as a clothing and shoe store at 928–930 B Street. George W. Steiner bought Pete Peterson's interest in 1914. In 1928, Al Blundell bought out Steiner's portion. Walter Trebert joined the organization in 1929 and became manager in 1932. In 1957, Trebert, Clark Norris, and E.H. Madsen bought the business from Emma Blundell and the descendants of Pete Peterson. The store got a new sign when it was remodeled in 1957. (Sparks Museum.)

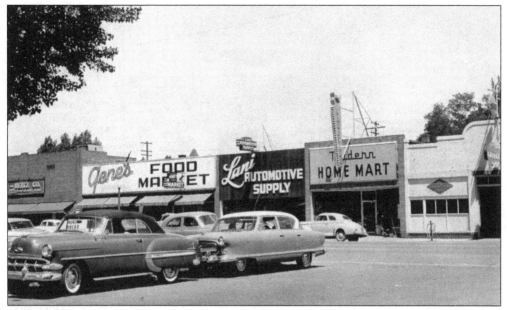

Sprouse-Reitz Company Variety Store, Gene's Food Market, Lani Automotive Supply, and Modern Home Mart are shown in 1949. Sprouse-Reitz opened on the corner of Thirteenth and B Streets but moved to this location when the Shelly family built a new store. Gino C. Pisani ran Gene's Food Market from 1949 until 1974. J.K. Gardner and Orlan H. Sanders opened Lani Automotive in 1949. Lani Automotive later became Allied Automotive. (Sparks Museum.)

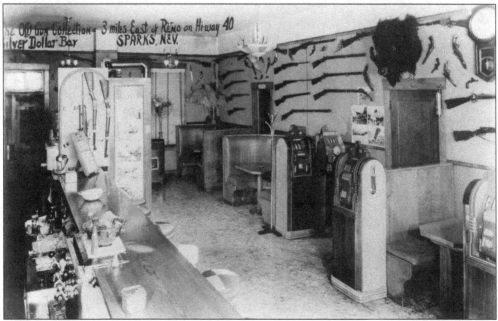

The Silver Dollar Bar, located at 1220 B Street, opened in May 1904. George Hopkins owned the bar from 1934 to 1957. Hopkins decorated the bar with his collection of antique guns, powder horns, knives, and bayonets. His collection even included a flintlock with a barrel the size of a nickel made by Samuel North, the first man to make guns in the United States. Note the slot machines at the end of each booth. (Jerry Fenwick.)

T.F. Gee opened the Chinese Pagoda restaurant in the former Youngs' Hotel on the corner of Eighth and B Streets in November 1946 and served "Deluxe Chinese and American dinners." A home delivery service began in May 1948. In 1964, the Sparks restaurant closed, then reopened on South Virginia Street in Reno. (Sparks Museum.)

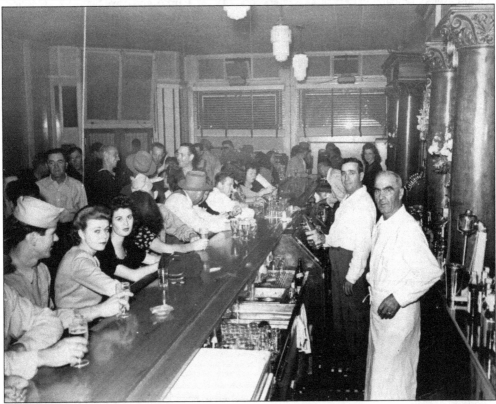

Joe Puccinelli owned the Crystal Bar at 1002 B Street in the 1940s. The Crystal Bar was in the Robison building. Here, Frank Sarcelli is tending bar, and Angie Puccinelli is at the end of the bar. The Crystal Bar had dancing on Saturday nights. This was a Safeway grocery in the 1930s; Joe and Carl Puccinelli renovated the grocery store building to house the bar. (Sparks Museum.)

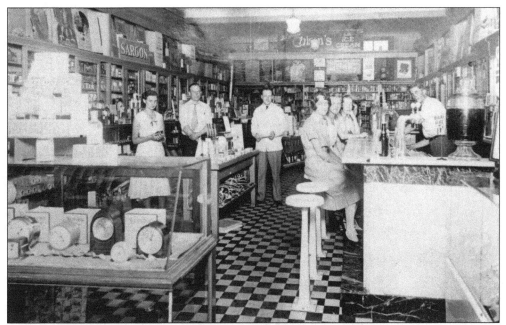

George A. Southworth and Ray Fleming of Reno purchased Schramm-Johnson Drug in Sparks to open the Sparks Union Drug Company in 1930. In 1935, the store, located at 938 B Street, sold Chism's Ice Cream at its fountain and Rexall Drug products such as theatrical cold cream and Rexall toilet soap. The store became Hilp's Drugs in the late 1930s. (Sparks Museum.)

Daniel Fodrin was elected mayor of Sparks in May 1939. He appointed A.J. Bassemier as chief of police, E.R. Simms as police judge, and W.R. Shaber as fire chief. The city street commissioners were Charles Morby and Cliff Joslin. George Steiner and S.H. Burgess were named police commissioners. Fodrin served as mayor from 1939 to 1947 and again from 1951 to 1953. (Sparks Museum.)

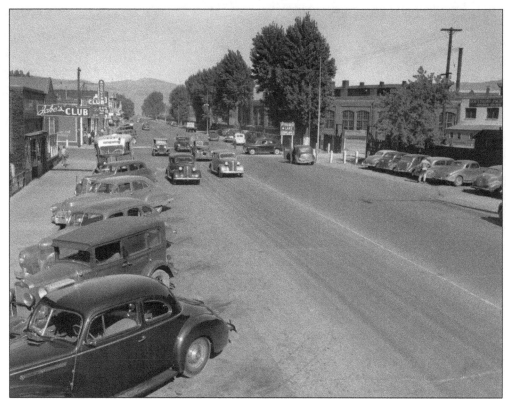

B Street, once known as Harriman Avenue and now Victorian Avenue, runs east and west through Sparks and was made part of the transcontinental highway, US 40, in 1934. The north side of B Street bounded the main business district. The Sparks City Council asked Southern Pacific to approve the south side of B Street as a business district in 1945. Trees planted on the entire length of B Street in 1908 were maintained by the chief of police's chain gang. (Sparks Museum.)

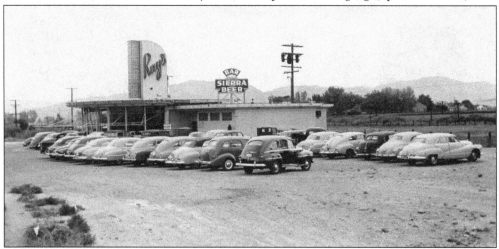

Ray's Drive-In Bar opened in June 1947 at the Y on Prater Way and B Street. Social clubs, such as the Sparks Welcome Wagon, held luncheon and dinner meetings in the Gaynor banquet room. The Sparks Chamber of Commerce held a 50th anniversary dinner for Sparks in the Gaynor room on March 15, 1955. Ray's closed in 1958. (Sparks Museum.)

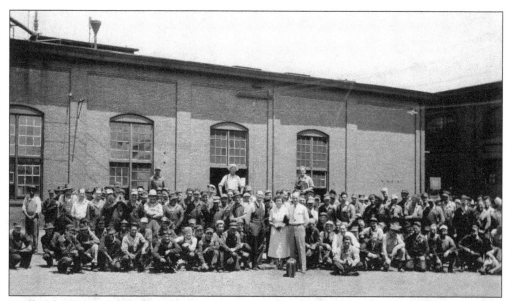

Staff of the Southern Pacific rail yards are shown in front of the repair shops on July 30, 1949. The Sparks yards stretched over 2,000 acres. The railroad was the biggest industry and employer in Sparks for over 54 years. In 1950, Sparks was the third-largest city in Nevada, with a population of 8,203, and by 1955, it contained approximately 12,000 people. The railroad closed the roundhouse and shops in 1957. (Sparks Museum.)

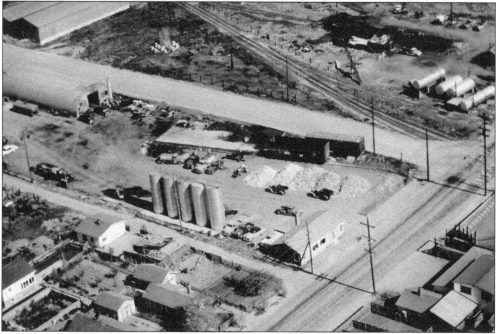

Charles B. Norris moved to Sparks in 1920 to work in the railroad shops. In 1935, Norris started the Norris Fuel Company at 321 South Seventeenth Street and sold fuel oil, wood, and coal to residential and commercial customers. Norris's obituary in the *Reno Gazette Journal* on January 13, 1979, reported that "his first deliveries were made with a Model T truck carrying 50 gallon drums." The Norris Fuel Yard and the Sparks Fuel Yard are shown here in 1956. (Sparks Museum.)

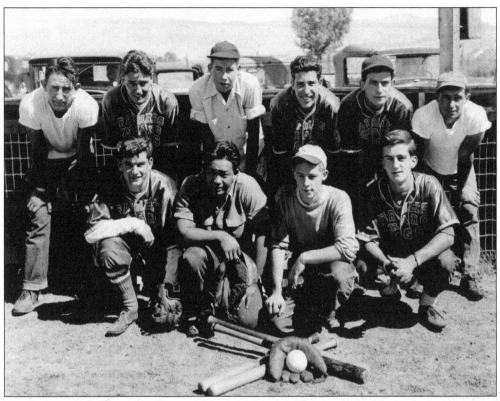

The Farmers' Exchange softball team played the Sparks All Stars during the 40th anniversary of Sparks on Labor Day in 1944. The Farmers' Exchange players pictured here are, from left to right, (first row) unidentified, Jim Chikami, and two unidentified; (second row) Art Olivera, unidentified, Marshall Reed, James Bart, Art Herring, and unidentified. (Sparks Museum.)

Groundbreaking for the Greenbrae Terrace Shopping Center, the first shopping center in Sparks, was held in August 1957 at the old Sparks Airpark location on Greenbrae and Pyramid Way. Frank Green, architect for the shopping center, stated that it would "encompass the best known advantages of suburban shopping centers in such areas as Sacramento, Stockton, and suburban Los Angeles." The developers were George A. Probasco (left) and Harold Munley (right) of Realty Investment Incorporation. (Sparks Museum.)

Greenbrae Terrace Shopping Center was scheduled to have four units covering approximately 20 acres and cost more than $1 million. An old hangar from Sparks Airpark was used for one of the stores. Sprouse-Reitz, Pettis Pharmacy, Russell's Beauty Salon, Banks TV and Appliance, and Hanson's Market opened in January 1958. A parking lot could accommodate 700 automobiles. Here, Barbara Shelley is kneeling and Al Sutherland is in the center. (Sparks Museum.)

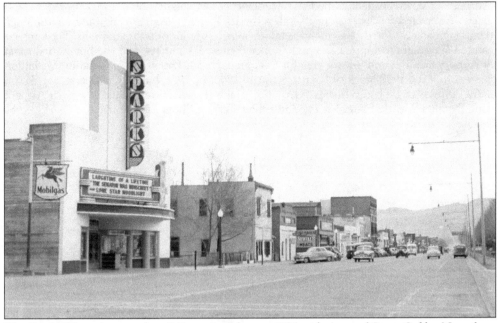

The Sparks Theater opened on B Street in February 1935 with *Anne of Green Gables*. Next door, in the space showing an empty lot in this 1948 photograph, was a new candy store owned by Mr. and Mrs. R. Irwin. Duane Moore and Ron Palmer, Reno Realty Company owners, converted the theater into the King of Clubs casino, which opened in May 1975. (NHS.)

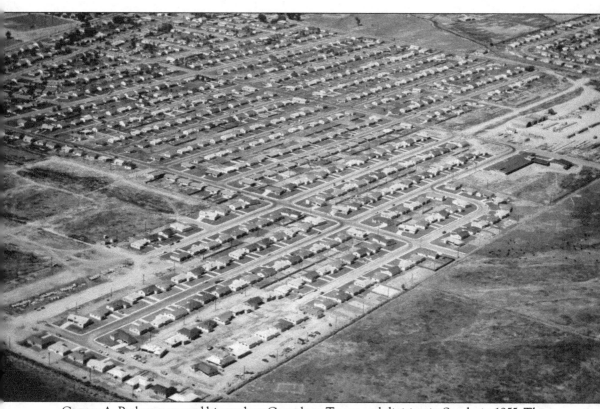

George A. Probasco opened his modern Greenbrae Terrace subdivision in Sparks in 1955. These homes were described as "built around family activities—around sleeping, eating and entertaining." Many of the homes were three- or four-bedroom homes with one or two bathrooms. The kitchens featured Westinghouse appliances and Youngstown steel cabinets, and the homes had room for laundry facilities and a work area for food preparation. Probasco was building Medallion Homes off of the 1900 block of Fourth Street in 1960. By 1961, half of the Sparks population of 17,000 lived in Probasco homes. This photograph shows the terminals at Sparks Airpark along Pyramid Way that later became Greenbrae Terrace Shopping Center, also developed by Probasco. (Sparks Museum.)

Champion flagpole sitter Happy Bill Howard began his stay on a "seven-by-seven foot nugget shaped platform" on top of a 65-foot flag pole on August 4, 1955, at the B Street Park across from The Nugget, owned by Dick Graves. Graves agreed to pay Howard $6,800 to break his record of 196 days. After 205 days atop the pole, Howard was picked up by a helicopter on February 25, 1956. The City of Sparks proclaimed February 25, 1956, "Bill Howard Day." (Sparks Museum.)

Dick Graves opened a 60-seat coffee shop with 50 slot machines on the north side of B Street on March 17, 1955. Free parking was available next to Modern Home Mart. Graves's trademark "Last Chance Joe" advertised the business by saying, "More Room for More Players More Winners" and "Ya Gotta Send Out Winners to Get Players." The Coffee Shop offered a steak sandwich for $1.15 and an Awful Awful hamburger with fries for 65¢. (Sparks Museum.)

Bertha and Tina, the Nugget goodwill ambassador elephants, are taking a bath in their water hole near the casino in the mid-1960s. Nugget owner John Ascuaga purchased Bertha, a former circus elephant, in 1962, and she performed until her death in 1999. Tina was two when Graves purchased her in 1967. Bertha and Tina performed with many headliners in the Circus Room. (NHS.)

Trader Dick's, named for Dick Graves, opened on the north side of B Street at Twelfth Street in December 1958 and moved across the street to the south side of B Street (in the present Nugget building) in 1973. Advertisements promised "a unique approach to South Seas, Cantonese and American cooking in the authentic atmosphere of the Pacific Islands." (NHS.)

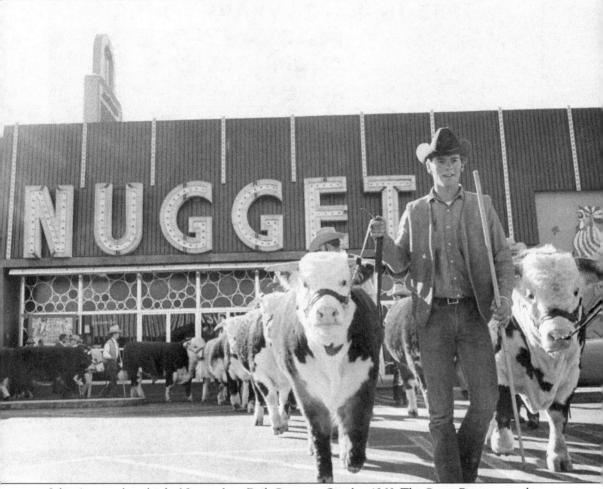

John Ascuaga bought the Nugget from Dick Graves in October 1960. The Circus Room opened in June 1962 and the Roof Garden Hotel in July 1962. The Nugget held an annual Western Nugget National Hereford Show and Sale in the Celebrity Room beginning in 1969. Shown is a "bull parade" crossing B Street in 1974. John Ascuaga's Meat Plant opened in 1976, selling meat to casinos and restaurants in northern Nevada. The Nugget became a major convention destination when an 80,000-square-foot hotel and convention center opened in August 1989. The West Tower opened in December 1996 with more convention space and 100 suites. (NHS.)

1955-1988 — 33 YEARS YOUNG

The Nugget celebrated its 33-year anniversary in 1988. On May 13, 1958, The Nugget moved to the south side of B Street to a 36,000-square-foot casino with five restaurants, two bars, and banquet rooms. Dick Graves sold the Nugget to John Ascuaga for $3.775 million on October 1, 1960. The Circus Room opened in June 1962 and featured headliners such as Jimmy Durante, Dinah Shore, Red Skelton, and Liberace. The first Nugget hotel tower opened in December 1984 with 610 rooms. (NHS.)

Harold Lucey, Gino Quilici, and Robert Benedetti renovated the old Sprouse-Reitz building on B Street for their new Mint casino in April 1972. Lucey and Quilici owned the Copenhagen Bar on Prater Way. The Mint originally had a bar, gift shop, snack bar, and slots. Fred Onorato and his family bought the casino with approval by the State Gaming Control Board in February 1978. The Mint closed in December 1981 after Onorato filed for bankruptcy on July 22, 1981. The building was demolished in 2010. (NHS.)

The King of Clubs opened in the location of the old Sparks Theater on B Street in May 1975. Duane Moore and Ron Palmer, managers of the casino, planned to hire 90 people. The *Reno Gazette Journal* went in search of the best 99¢ breakfast in October 1979 and rated the King of Clubs, located at 1324 B Street, as one of the best. One diner proclaimed that the casino had "the best food, cooks and waitresses in the state." (NHS.)

Karl Berge purchased the old Sparks Silver Club at 1040 B Street in July 1967. He expanded the casino in March 1972 by taking over space occupied by Sparks Shoe Service to make room for a Keno lounge. Berge traded in two of his Big Bertha quarter slot machines for Bally dollar slot machines that had a 90-percent payout rather than a 60-percent payout. Berge later added a 19-slot carousel with a payout of 95 percent. Customers in this photograph are enjoying steaks in the club's Victoria's Steak House. (NHS.)

Frank Marazita (left), the food and beverage manager at the Silver Club Hotel Casino, is shown in 1992 with "Keno the Cow." The "I Love New York" t-shirt was because Marazita had just moved from New York to Nevada. The Silver Club was well known for its steak dinners. (NHS.)

Tony Pecetti opened the El Rancho Drive-In on property between Reno and Sparks in August 1950. The first movie shown was *My Foolish Heart.* An advertisement in the August 19, 1950, *Reno Gazette Journal* proclaimed: "the most modern drive-in theater in Nevada, Largest Screen, Perfect Vision, Newest RCA Projection, Latest RCA in-the-car speakers." El Rancho Drive-In is at the corner of El Rancho Drive and G Street next to Teglia's Paradise Park ponds. (Sparks Museum.)

Limited hydroplane races were held at Paradise Park, considered Nevada's first marine stadium, in the 1960s and 1970s. In 1964, Reno, Sparks, and Washoe County bought the 50-acre Paradise Park, or Teglia's ponds, on Oddie Boulevard east of the Reno city limits from Roger Teglia. The park had four lakes connected by channels, and the largest lake was used for hydroplane races. (Sparks Museum.)

In October 1964, the National Centennial Regatta hydroplane races were held at Paradise Park. The limited hydroplanes were 10 feet in length and could travel up to 100 miles per hour. The hydroplanes, with engines from 15 cubic inches to 60 cubic inches, would make five laps around the pond. Brothers Jim and Fred Hauenstein, national champions in the "C" Service and "C" Racing classes, were featured. (Sparks Museum.)

BIBLIOGRAPHY

Beck, James H. *Rail Talk: A Lexicon of Railroad Language.* Gretna, NE: James Publications, 1978.

Beebe, Lucius. *The Central Pacific & the Southern Pacific Railroads.* Berkeley, CA: Howell-North Books, 1963.

Earl, Phillip I. "Sparks Goes to War: A Story of the Home Front, 1941–1945" (Part I). *Washoe Rambler: Journal of the Washoe County Historical Society,* 3.2, Fall 1979.

———. "Sparks Goes to War: A Story of the Home Front, 1941–1945" (Part II). *Washoe Rambler: Journal of the Washoe County Historical Society,* 3.3, Winter 1979.

Fenwick, Jerry L. "The Day the Flying Circus Came to Reno." *Nevada in the West,* Vol. 6, No. 1, Spring 2015, pp. 14–19.

Fifty Years of Memories: John Ascuaga's Nugget, 1955–2005. Piedmont Pub., 2004.

Kingsbury, F.B. "Pioneer Days in Sparks and Vicinity: Early Settlers and Points of Interest." *Nevada State Historical Society Papers, 1925–1926.* Reno, NV: Nevada State Historical Society, 1926.

McLennan, A.D. "Salt Lake Division Main Line: The Steam Years, 1904–1956." *SP Trainline,* No. 73, Fall 2002.

Mullaly, Larry. "Down at the Roundhouse: Southern Pacific Engine Service During the Age of Steam." *SP Trainline,* No. 58, Winter 1998.

Myrick, David F. *Railroads of Nevada and Eastern California, Vol. 1: The Northern Roads.* Berkeley, CA: Howell-North Books, 1962.

Sparks Centennial History Book Committee. *History of Sparks: Centennial Edition.* Sparks, NV: Sparks Centennial Commission, 2004

Storm, Donald. "The Nevada Physical Facilities of the Transcontinental Central and Southern Pacific Railroads, Part 1." *SP Trainline,* No. 34, Winter 1993.

———. "The Nevada Physical Facilities of the Transcontinental Central and Southern Pacific Railroads, Part 2." *SP Trainline,* No. 36, Summer 1993.

———. "The Nevada Physical Facilities of the Transcontinental Central and Southern Pacific Railroads, Part 3." *SP Trainline,* No. 37, Fall 1993.

ABOUT THE SPARKS HERITAGE FOUNDATION AND MUSEUM

The Sparks Heritage Foundation and Museum Inc. was established on April 1, 1985, as an independent nonprofit 501(c)(3). The organization's mission is to preserve the historical and cultural heritage of Sparks and the Truckee Meadows for the education and enjoyment of present and future generations.

The museum quickly outgrew its first home in the basement of Sparks City Hall; recognizing the museum's importance, the City of Sparks provided a storefront at 820 Victorian Avenue. In 1995, the museum expanded its facilities to include the nationally registered historic building next door at 814 Victorian Avenue, formerly the Sparks Public Library and then the Sparks Justice Court building.

Today, as the Sparks Museum and Cultural Center, the two buildings house a cultural center, archival research library, and engaging exhibits that connect community members and visitors to the rich heritage and diversity of Sparks and the Truckee Meadows. The museum facility also includes the nationally registered historic Glendale Schoolhouse and an outdoor train exhibit comprised of a steam locomotive, a cupola caboose, and a Pullman executive car. Using artifacts to tell the story, the exhibits illustrate the rapid changes the region has undergone, from ranching and mining to the introduction of the railroad and into modern times.

Volunteers are vital to the Sparks Museum for the countless hours of time they give in support of museum operations and projects, both large and small. The museum continues to grow and serve the community by offering enriching arts and culture programs and museum activities, not only to preserve the values on which Sparks was founded, but to educate and strengthen the next generation. The museum's continued success can be attributed to support from the City of Sparks, the community, museum members, volunteers, and donors.

For more information, visit the museum website at sparksmuseum.org or call 775-355-1144.

DISCOVER THOUSANDS OF LOCAL HISTORY BOOKS
FEATURING MILLIONS OF VINTAGE IMAGES

Arcadia Publishing, the leading local history publisher in the United States, is committed to making history accessible and meaningful through publishing books that celebrate and preserve the heritage of America's people and places.

Find more books like this at
www.arcadiapublishing.com

Search for your hometown history, your old stomping grounds, and even your favorite sports team.